CW00552876

Cool Restaurants
Cape Town

teNeues

Imprint

Editors: Ulrike Bauschke & Pascale Lauber

Editorial direction: Martin Nicholas Kunz

Editorial coordination: Gavin Dingle, Rosina Geiger

Photos (location): Pascale Lauber (95 Keerom, Africa Café, Anatoli, Baía Seafood Restaurant, barmooda, Beluga, Buena Vista Social Cafe, Bukhara, Cara Lazuli, Ginja, Greens on Park, Haiku, Madame Zingara, Manna Epicure, Manolo, Miam Miam, Pigalle, Relish, Rhodes House, Saigon, Savoy Cabbage, Tank, The Gallery Cafe, The Towers Club, Vida e Caffe, Wakame), courtesy 95 Keerom (food), Inness Mass (Baía Seafood Restaurant, food), courtesy Bukhara (food), Craig Hemphill (Cara Lazuli & Madame Zingara, food), courtesy Ginja (food), Gavin Dingle (Manna Epicure, page 62), courtesy Manolo (food), courtesy one.waterfront (food), Kara Lombard (Saigon, food), Dirk Peters (Savoy Cabbage, food), courtesy Arata Koga (food), Martin Nicholas Kunz (one.waterfont, Planet Champagne & Cocktail Bar)

Introduction: Gavin Dingle

Layout: Martin Nicholas Kunz

Imaging & Pre-press: Jeremy Ellington

Translations: SAW Communications, Dr. Sabine A. Werner, Mainz; Ulrike Brandhorst (Intro German), Brigitte Villaumié (French), Silvia Gomez de Antonio (Spanish), Maria-Letizia Haas (Italian)

Nina Hausberg (German / recipes)

Produced by fusion publishing GmbH, Stuttgart . Los Angeles www.fusion-publishing.com

Published by teNeues Publishing Group

teNeues Book Division
Kaistraße 18
40221 Düsseldorf, Germany
Tel.: 0049-(0)211-994597-0
Fax: 0049-(0)211-994597-40
E-mail: books@teneues.de

Press department:
arehn@teneues.de
Phone: 0049-2152-916-202

teNeues Publishing Company
16 West 22nd Street
New York, NY 10010, USA
Tel.: 001-212-627-9090
Fax: 001-212-627-9511

teNeues Publishing UK Ltd.
P.O. Box 402
West Byfleet
KT14 7ZF, Great Britain
Tel.: 0044-1932-403509
Fax: 0044-1932-403514

teNeues France S.A.R.L.
4, rue de Valence
75005 Paris, France
Tel.: 0033-1-55766205
Fax: 0033-1-55766419

teNeues Iberica S.L.
Pso. Juan de la Encina 2–48,
Urb. Club de Campo
28700 S.S.R.R. Madrid, Spain
Tel./Fax: 0034-91-65 95 876

www.teneues.com

ISBN-10: 3-8327-9103-5
ISBN-13: 978-3-8327-9103-2

© 2006 teNeues Verlag GmbH + Co. KG, Kempen

Printed in Italy

Bibliographic information published by Die Deutsche Bibliothek.
Die Deutsche Bibliothek lists this publication in the Deutsche Nationalbibliografie; detailed bibliographic data is available in the Internet at http://dnb.ddb.de.

Average price reflects the average cost for a dinner main course without beverages. Recipes serve four.

Contents Page

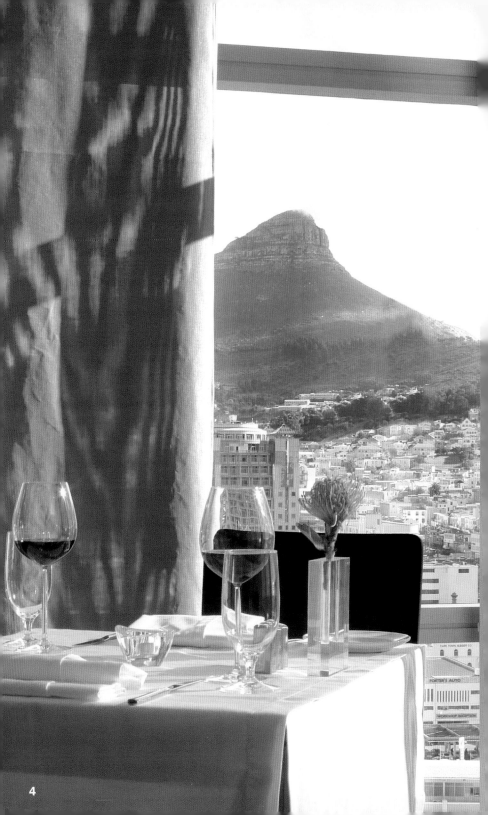

Introduction

Over the past three decades, Capetonians have seen culinary history come full circle. During the 80s, there were more than 150 restaurants in Sea Point's main road alone. You could pick a new place every week and never eat the same dish twice. Then, during the political uncertainty of the 90s, patrons were lucky if any new places remained open for a second visit. Some presented an enormous sea-food buffet. Others offered fish-bowl sized cocktails or were filled with beautiful models, relaxing after a hard day in front of the camera. But, these temptations were not enough to keep many establishments running for longer than six months. The year 2000 brought new hope to the hospitality industry. A peaceful transition to a democratic government brought visitors pouring in to celebrate the turn of the century. New world-class eateries opened everywhere, and increased tourism raised standards to an all-time high. *Cool Restaurants Cape Town* shows the eclectic mix of venues, representing every nationality imaginable. Traditional Indian dishes are offered by eateries like Bukhara. Anatoli serves a huge assortment of mezes in festive, Turkish surroundings. Saigon pampers its guests with Vietnamese dishes, and Buena Vista provides an authentic Cuban atmosphere for Mojitos and Caribbean delights. Environment contributes greatly to culinary enjoyment. Wakame prepares fresh sushi while overlooking Robben Island. Guests of the exclusive Tower Club enjoy a vista of Cape Town's city lights, and Relish rewards patrons with an awesome view of Table Mountain. The understated decor in rooms like 95 Keerom and Greens on Park highlights their passionate dedication to food quality. The aroma of freshly baked bread completes the homely atmosphere of Manna Epicure, and the eccentric embellishments of Madame Zingara compliment her adventurous menu. Whether it's lunch within the undressed brick walls of Savoy Cabbage, or an evening in the flamboyance of Pigalle, Cape Town has a venue to excite your senses of style and taste.

Gavin Dingle

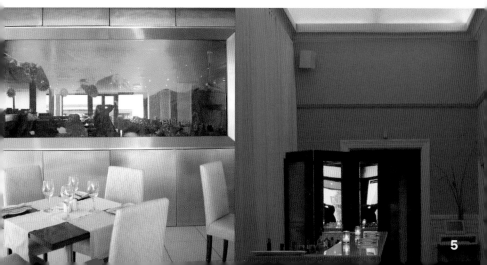

Einleitung

In den letzten drei Jahrzehnten erlebten die Einwohner von Kapstadt, dass sich der Kreis der kulinarischen Entwicklung ihrer Stadt schloss. Während der Achtzigerjahre gab es allein an der Hauptstraße von Sea Point mehr als 150 Restaurants. Man konnte jede Woche ein neues Lokal besuchen und musste niemals das gleiche Gericht zweimal essen. Dann, in der politischen Unsicherheit der Neunziger, konnten Gäste von Glück reden, wenn sie überhaupt Gelegenheit zu einem zweiten Besuch in einem kurz zuvor eröffneten Restaurant hatten. Einige von ihnen boten riesige Buffets mit Meeresfrüchten, andere servierten Cocktails in der Größe von Goldfischgläsern oder aber waren voll von Models, die sich nach einem harten Tag vor der Kamera entspannten. Doch trotz all dieser Verlockungen überlebten viele dieser Restaurants nicht länger als ein halbes Jahr. Das Jahr 2000 brachte der Gastronomiebranche neue Hoffnung. Der friedliche Übergang zu einer demokratischen Regierung ließ Besucher zur Feier der Jahrtausendwende scharenweise herbeiströmen. Überall eröffneten neue Welt-Klasse-Restaurants und der wachsende Tourismus sorgte für einen stets gleich bleibend hohen Standard. *Cool Restaurants Cape Town* präsentiert eine vielseitige, bunte Mischung an Lokalen, in der jede nur denkbare Nationalität vertreten ist. Traditionelle indische Speisen werden in Restaurants wie dem Bukhara angeboten. Das Anatoli serviert eine riesige Auswahl an Mezes in einem festlichen türkischen Ambiente. Das Saigon verwöhnt seine Gäste mit vietnamesischen Gerichten und das Buena Vista bietet für den Genuss von Mojitos und karibischen Köstlichkeiten eine authentische kubanische Atmosphäre. Aber auch die Umgebung trägt sehr zum kulinarischen Genuss bei: Im Wakame kann man die Aussicht auf Robben Island genießen, während das Sushi frisch zubereitet wird. Gäste des exklusiven Tower Clubs genießen den Blick auf die Lichter von Kapstadt und das Relish belohnt seine Kunden mit einem beeindruckenden Blick auf den Tafelberg. Die schlichte Einrichtung des 95 Keerom und des Greens on Park unterstreicht deren leidenschaftliche Hingabe an die Qualität der Gerichte. Der Duft von frisch gebackenem Brot macht die gemütliche Atmosphäre des Manna Epicures vollkommen und die exzentrische Dekoration von Madame Zingara schmeichelt den dort servierten experimentierfreudigen Gerichten. Ob es ein Lunch im Savoy Cabage mit seinen unverkleideten Ziegelsteinmauern ist oder ein Abend im extravaganten Pigalle, Kapstadt bietet eine ganze Reihe von Treffpunkten, die ihr Stilempfinden ansprechen und ihren Geschmackssinn betören werden.

Gavin Dingle

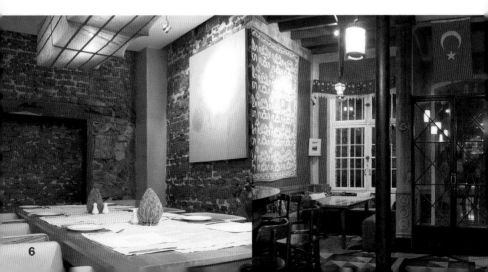

Introduction

Au cours de trois dernières décennies les habitants du Cap virent se boucler la boucle de l'évolution gastronomique de leur ville. Dans les années 80, il y avait dans la seule rue principale de Sea Point plus de 150 restaurants. Chaque semaine on pouvait se rendre dans un nouvel établissement et on ne mangeait jamais deux fois le même plat. Puis, dans l'insécurité politique des années 90, les clients purent s'estimer heureux d'avoir l'occasion de retourner une seconde fois dans l'un des restaurants qui avait ouvert peu de temps auparavant. Certains proposaient d'énormes buffets de fruits de mer, d'autres servaient des cocktails dans des verres aussi grands qu'un bocal à poisson et d'autres encore étaient peuplés de top-modèles venus se détendre après une rude journée devant la caméra. Cependant, malgré tous ces attraits, nombre de ces restaurants ne survécurent pas plus de six mois. L'an 2000 apporta un nouvel espoir au secteur de la gastronomie. La transition pacifique vers un gouvernement démocratique contribua à faire affluer les visiteurs pour fêter le passage au nouveau millénaire. Partout s'ouvrirent de nouveaux restaurants de classe internationale et le développement du tourisme garantit un standard de qualité élevé et constant. *Cool Restaurants Cape Town* présente un éventail varié et coloré d'établissements où toutes les nationalités imaginables sont représentées. Des restaurants comme le Bukhara proposent des plats indiens traditionnels. L'Anatoli sert une grande variété de mezes dans une atmosphère de fête turque. Le Saigon ravit ses hôtes avec des plats vietnamiens et le Buena Vista garantit, pour déguster des mojitos et des délices des Caraïbes, une authentique atmosphère cubaine. Le décor aussi exalte encore les plaisirs culinaires : au Wakame, l'hôte contemple le panorama de Robben Island tandis que devant lui se prépare le sushi. Les visiteurs de l'exclusif Tower Club admirent les lumières du Cap et le Relish récompense ses clients avec une vue impressionnante sur le Tafelberg. Le sobre aménagement du 95 Keerom et du Greens on Park souligne la passion qu'ils vouent à la qualité des plats. L'odeur du pain fraîchement cuit crée l'atmosphère conviviale de Manna Epicure et la décoration excentrique de Madame Zingara flatte les mets inventifs qui y sont servis. Qu'il s'agisse d'un déjeuner au Savoy Cabbage avec ses murs de briques apparentes ou d'une soirée dans l'extravagant Pigalle, Le Cap offre de multiples points de rencontre qui interpelleront votre sens du style tout en ravissant votre palais.

Gavin Dingle

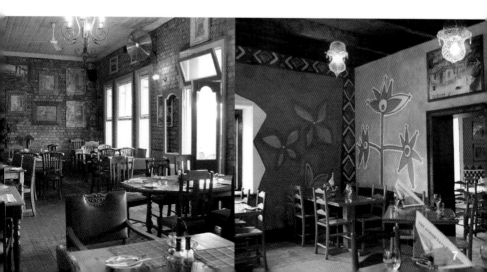

Introducción

En las tres últimas décadas los habitantes de la Ciudad del Cabo han visto como el círculo del desarrollo culinario de su ciudad se cerraba. En la década de 1980 sólo en la calle principal de Sea Point había más de 150 restaurantes. Entonces era posible ir cada semana a un local nuevo y no era necesario repetir dos veces el mismo plato. Después, en la inseguridad política de los noventa, los visitantes podían hablar de suerte si tenían la oportunidad de comer dos veces en uno de los restaurantes recién inaugurados. Algunos de ellos ofrecían impresionantes bufés de marisco, otros servían cócteles del tamaño de peceras o estaban llenos de modelos que se relajaban después de un duro día de trabajo delante de las cámaras. Pero a pesar de estas tentaciones muchos de los restaurantes no sobrevivían más de medio año. El año 2000 trajo consigo nuevas esperanzas para el sector gastronómico. La pacífica transición a un gobierno democrático permitió la llegada en masa de visitantes que querían celebrar el cambio de milenio. Por todas partes se inauguraron nuevos restaurantes de clase mundial y el aumento del turismo permitió mantener un elevado estándar. *Cool Restaurants Cape Town* presenta una variada y colorida mezcla de locales que representan todas las nacionalidades imaginables. En restaurantes como el Bukhara se preparan platos indios tradicionales. El Anatoli sirve una extraordinaria selección de mezes (entrantes) en un alegre ambiente turco. El Saigon ofrece a sus huéspedes platos vietnamitas y el Buena Vista prepara mojitos y delicias caribeñas en una atmósfera cubana. Pero el entorno también ayuda a gozar del placer gastronómico: En Wakame se puede disfrutar de la vista sobre Robben Island mientras preparan el sushi fresco. Los comensales del exclusivo Tower Club pueden deleitarse de las vistas sobre las luces de la Ciudad del Cabo y el Relish premia a sus visitantes con una extraordinaria panorámica sobre la Montaña de la Mesa. La sencilla decoración del 95 Keerom y del Greens on Park subraya la pasión por la calidad de los platos. El aroma del pan recién cocido da una nota acogedora a la atmósfera del Manna Epicuro y la excéntrica decoración del Madame Zingara es un halago a los platos experimentales que aquí se sirven. Tanto si se quiere almorzar en el Savoy Cabage con sus muros descubiertos de ladrillo o cenar en el extravagante Pigalle, la Ciudad del Cabo ofrece un gran número de lugares de encuentro acordes con su estilo o que fascinarán su sentido del gusto.

Gavin Dingle

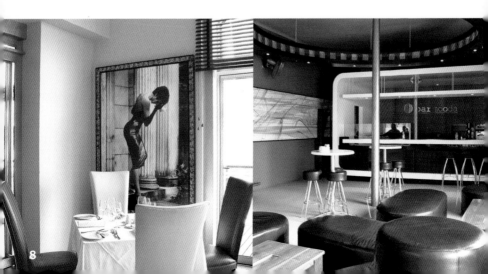

Introduzione

Gli abitanti di Città del Capo hanno visto compiersi lo sviluppo culinario della loro città nell'arco degli ultimi trent'anni. Durante gli anni ottanta, solo nella strada principale di Sea Point esistevano più di 150 ristoranti: si poteva scegliere ogni settimana un nuovo locale senza dove mangiare due volte lo stesso piatto. Più tardi, nell'insicurezza politica degli anni novanta, divenne una fortuna riuscire a frequentare due volte un ristorante aperto da poco. Alcuni di questi locali offrivano ricchissimi buffet di frutti di mare, altri servivano cocktail in bicchieri grandi come vasi per pesci, o erano pieni di top-model che si concedevano una pausa di relax dopo una dura giornata passata davanti alla macchina fotografica. Ma, nonostante tutte queste attrazioni, molti ristoranti non sopravvivevano per più di sei mesi. Il 2000 ha portato al settore gastronomico nuove speranze. Grazie al pacifico passaggio al governo democratico, schiere di turisti sono accorse qui a festeggiare il nuovo millennio. Nuovi ristoranti di prim'ordine sono sorti ovunque ed il turismo crescente ha fatto sì che il loro standard, già alto, restasse sempre costante. *Cool Restaurants Cape Town* presenta un mix vario e colorato di locali di ogni nazionalità possibile ed immaginabile. Piatti indiani tradizionali sono la specialità di ristoranti come il Bukhara; l'Anatoli serve una grande varietà di mezes in un festoso ambiente turco; il Saigon vizia gli ospiti con ricette vietnamite, mentre il Buena Vista invita a gustare mojitos e prelibatezze caraibiche in un'autentica atmosfera cubana. Ma anche i dintorni invitano ai piaceri della tavola: al Wakame si gode la vista su Robben Island mentre in cucina viene preparato il sushi. Gli ospiti dell'esclusivo Tower Club possono ammirare le luci di Città del Capo, il Relish regala ai suoi clienti la magnifica vista del Tafelberg. L'arredamento sobrio del 95 Keerom e del Greens on Park sottolinea l'attenzione e la passione che la loro cucina dedica alla qualità dei piatti. Il profumo del pane fresco pervade l'accogliente atmosfera del Manna Epicures, mentre stravaganti decorazioni fanno da cornice agli insoliti menu del Madame Zingara. Che si tratti di un pranzo al Savoy Cabage, con le sue pareti dai mattoni a vista, o di una serata al particolarissimo Pigalle, Città del Capo offre innumerevoli punti d'incontro che sedurranno il vostro gusto deliziando il vostro palato.

Gavin Dingle

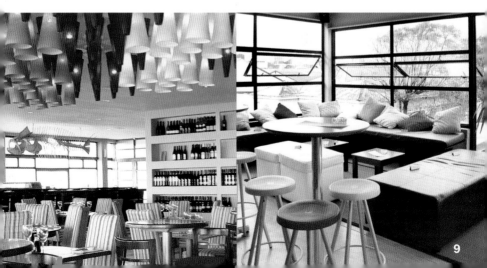

95 Keerom

Design: Inhouse Brand Architects Cape Town, Giorgio Nava
Chef, Owner: Giorgio Nava

95 Keerom Street | City Centre, 8001 | Cape Town
Phone: +27 21 422 0765
info@rhodeshouse.com
Opening hours: Mon–Fri noon to 2:30 pm, Mon–Sat 7 pm to 10 pm
Average price: R 150
Cuisine: Milanese (Italian)
Special features: Connection to Rhodes House night club

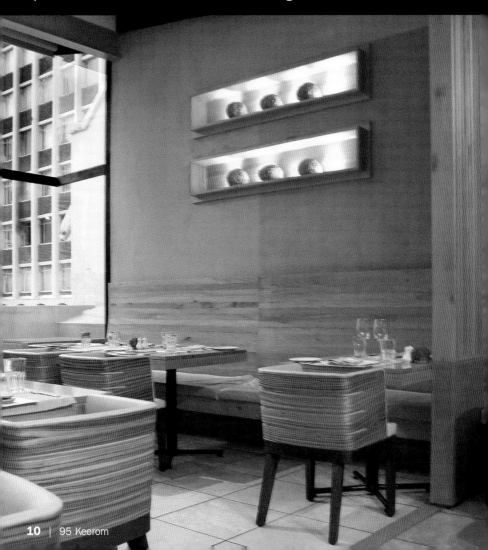

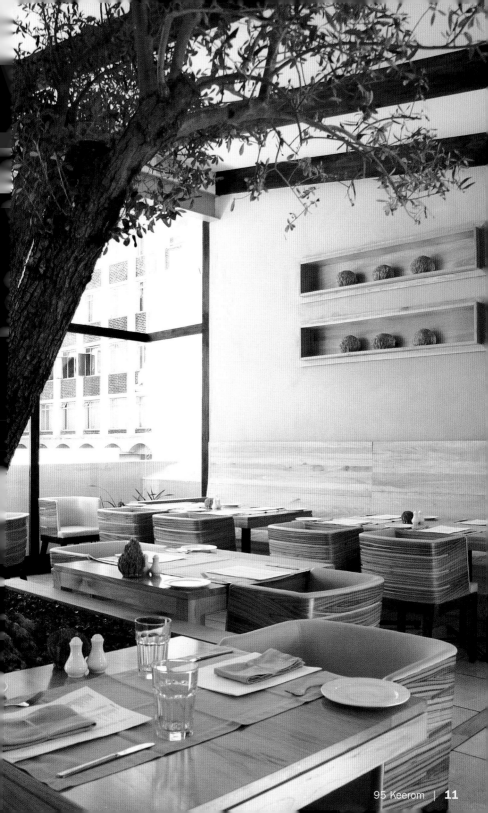

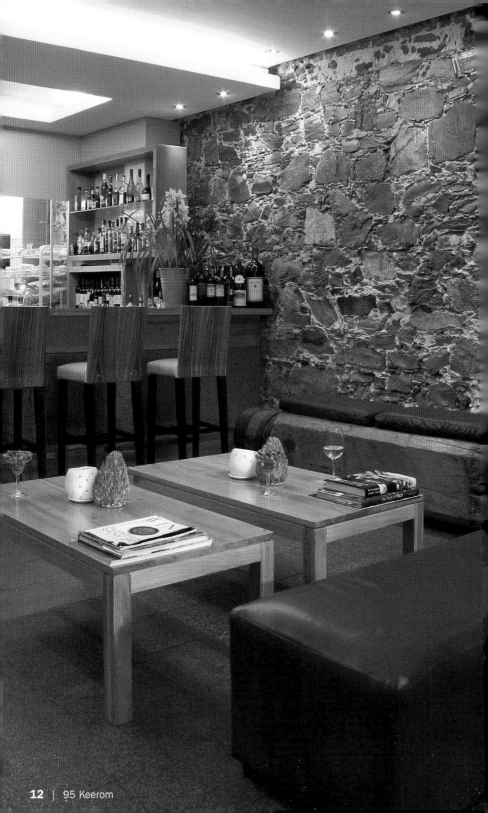

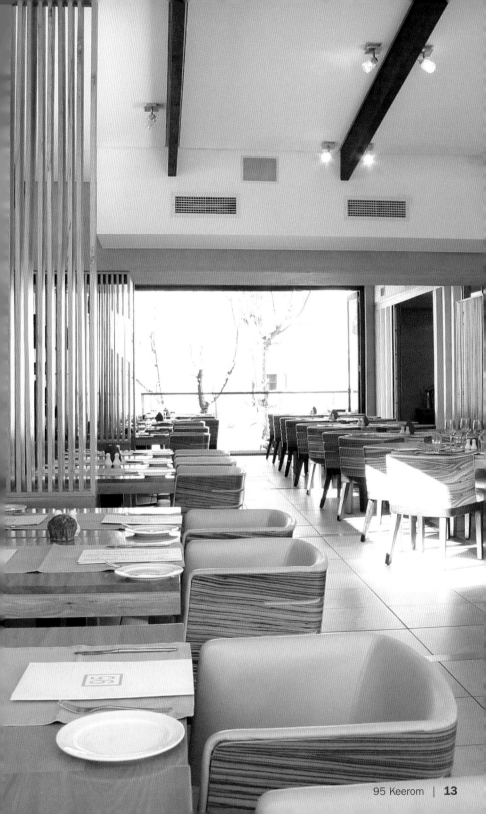

Stuffed Pork Neck Roll

Gefüllter Schweinerollbraten

Rôti de porc roulé farci

Rollitos de cerdo asados y rellenos

Rollè di maiale ripieno

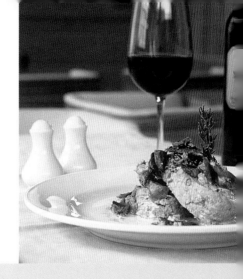

2 lb 3 oz pork neck
6 1/2 oz ricotta cheese
6 1/2 oz spinach, blanched and squeezed
4 tbsp olive oil
Salt, pepper
14 oz button mushrooms
1 oz dried edible boletus, ground
240 ml white wine
300 ml cream
1 tbsp lemon juice
4 twigs rosemary for decoration

Cut the pork neck to spread it out flat. Spread the ricotta cheese and spinach on it and season. Shape the meat into a roll and wrap tight with a string. Season again with salt and pepper. Heat the olive oil in a covered pan. Sear the pork roll from all sides. Add the mushrooms and the edible boletus and sear for 5 minutes. Add white wine to the roast and braise covered on a low flame for 1 1/2 hours.
Remove the roast from the sauce and keep warm. Fill up the sauce with the cream, reduce and season with salt, pepper and lemon juice.
Cut the pork roll into eight slices and divide onto four plates. Drizzle with sauce and garnish with a twig of rosemary.

1 kg Schweinehals
180 g Ricotta
180 g Spinat, blanchiert und ausgedrückt
4 EL Olivenöl
Salz, Pfeffer
400 g Champignons
30 g getrocknete Steinpilze, gemahlen
240 ml Weißwein
300 ml Sahne
1 EL Zitronensaft
4 Zweige Rosmarin zur Dekoration

Den Schweinehals so einschneiden, dass man ihn flach ausbreiten kann. Mit dem Ricotta und dem Spinat belegen und würzen. Das Fleisch zu einer Rolle formen und mit Küchengarn fest umwickeln. Nochmals salzen und pfeffern. Das Olivenöl in einer Pfanne mit Deckel erhitzen und den Rollbraten von allen Seiten scharf anbraten. Anschließend die Champignons und Steinpilze zugeben und 5 Minuten mitbraten. Mit Weißwein ablöschen und bei geschlossenem Deckel auf kleiner Flamme 1 ½ Stunden schmoren.
Den Braten aus der Sauce nehmen und warm stellen. Die Sauce mit der Sahne aufgießen, etwas einkochen lassen und mit Salz, Pfeffer und Zitronensaft abschmecken.
Den Schweinerollbraten in acht Scheiben schneiden und auf vier Teller verteilen. Mit der Sauce begießen und mit einem Rosmarinzweig garnieren.

1 kg d'échine de porc
180 g de ricotta
180 g d'épinards blanchis et pressés
4 c. à soupe d'huile d'olive
Sel, poivre
400 g de champignons
30 g de cèpes séchés moulus
240 ml de vin blanc
300 ml de crème
1 c. à soupe de jus de citron
4 branches de romarin pour la décoration

Inciser l'échine pour pouvoir l'étaler à plat. Garnir de ricotta et d'épinards et assaisonner. Rouler la viande en rôti et la ficeler fermement avec du fil de cuisine. Saler et poivrer de nouveau. Chauffer l'huile d'olive dans une poêle à couvert et saisir le rôti à feu vif sur toutes les faces. Ajouter ensuite les champignons et les cèpes et cuire ensemble 5 minutes. Mouiller au vin blanc et laisser mijoter à petit feu à couvert pendant 1 h 30. Retirer le rôti de la sauce et le mettre au chaud. Mouiller la sauce avec la crème, laisser cuire un instant et rectifier l'assaisonnement avec du sel, poivre et jus de citron. Couper le rôti roulé en huit tranches et les répartir sur quatre assiettes. Napper de sauce et garnir d'une branche de romarin.

1 kg de cuello de cerdo
180 g de ricota
180 g de espinacas, escaldadas y escurridas
4 cucharadas de aceite de oliva
Sal, pimienta
400 g de champiñones
30 g de boletos secos, molidos
240 ml de vino blanco
300 ml de nata
1 cucharada de zumo de limón
4 ramitas de romero para decorar

Corte el cuello de cerdo de tal forma que pueda extenderlo. Ponga encima la ricota y las espinacas. Haga un rollo con la carne y átelo con hilo de cocina para que no se abra. Salpiméntelo nuevamente. Caliente el aceite en una sartén tapada y fría bien el rollo de carne por todos los lados. Incorpore después los champiñones y los boletos y sofríalos durante 5 minutos. Corte la cocción con el vino blanco y deje hervir los ingredientes con la sartén tapada y a fuego lento durante 1 1/2 horas. Saque el asado de la salsa y resérvelo caliente. Añada la nata a la salsa y deje que hierva brevemente. Sazone con la sal, la pimienta y el zumo de limón. Corte el asado de cerdo en ocho rodajas y repártalas en cuatro platos. Vierta por encima la salsa y adorne con las ramitas de romero.

1 kg di collo di maiale
180 g di ricotta
180 g di spinaci scottati e strizzati
4 cucchiai di olio d'oliva
Sale, pepe
400 g di champignon
30 g di funghi porcini secchi macinati
240 ml di vino bianco
300 ml di panna
1 cucchiaio di succo di limone
Per la guarnizione: 4 ramoscelli di rosmarino

Tagliare il collo di maiale in modo da poterlo stendere. Ricoprirlo con la ricotta e gli spinaci e condirlo. Formare un rollè e legarlo bene con spago da cucina. Salare e pepare nuovamente. Riscaldare l'olio d'oliva in una padella con coperchio e rosolare il rollè a fuoco vivo da tutti i lati. Aggiungere quindi gli champignon ed i funghi porcini e farli appassire insieme per 5 minuti. Bagnare con il vino bianco e lasciar cuocere coperto a fuoco lento per 1 ora e mezza. Estrarre il rollè dalla salsa e tenerlo in caldo. Coprire la salsa con la panna, farla restringere un poco e condire con sale, pepe e succo di limone. Tagliare il rollè in otto fette e disporle su quattro piatti. Versarvi sopra la salsa e guarnire con un ramoscello di rosmarino.

Africa Café

Design: PoJaHeCi Design & do* | Chef: Portia de Smidt
Owners: Hector Mbau, Cindy Muller, Jason & Portia De Smidt

108 Shortmarket Street | City Centre, 8001 | Cape Town
Phone: +27 21 422 0221
www.africacafe.co.za
Opening hours: In season Mon–Sun 6:30 pm to midnight
Average price: R 150 (menu)
Cuisine: Afro-Elegant
Special features: Every dining room has a special African theme

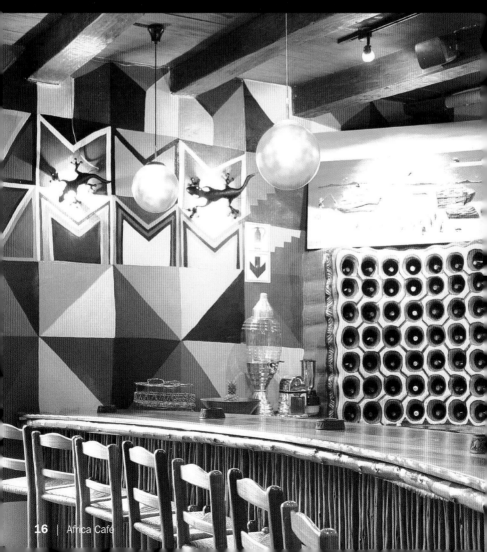

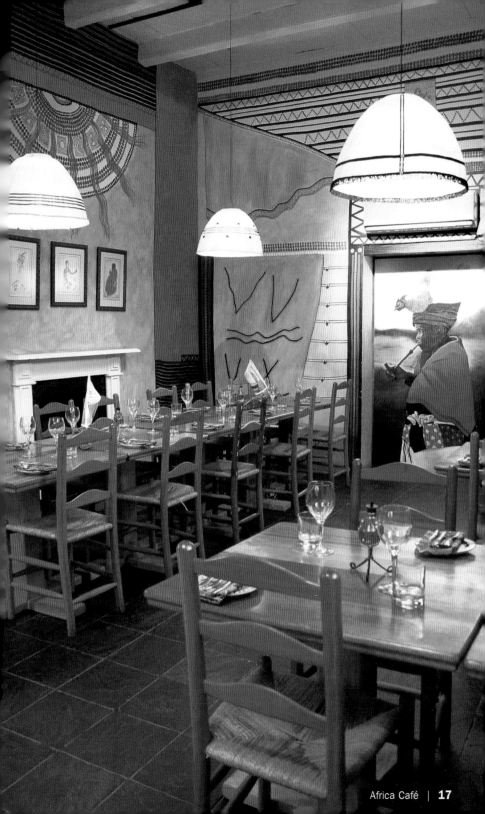

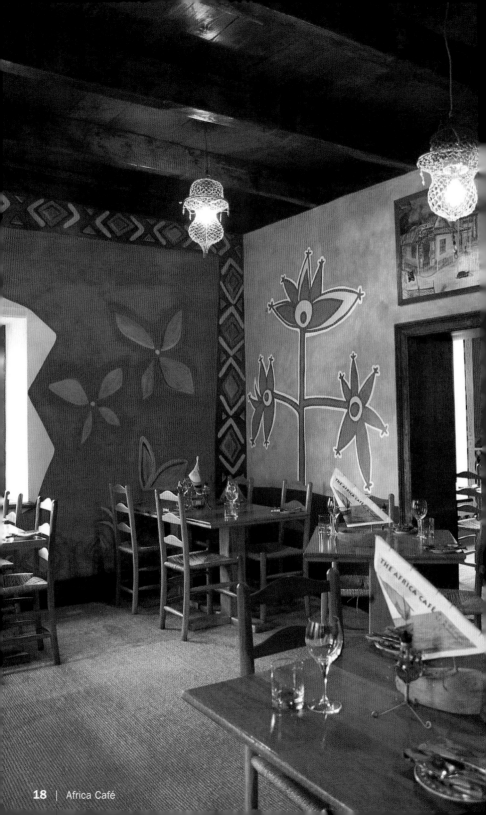

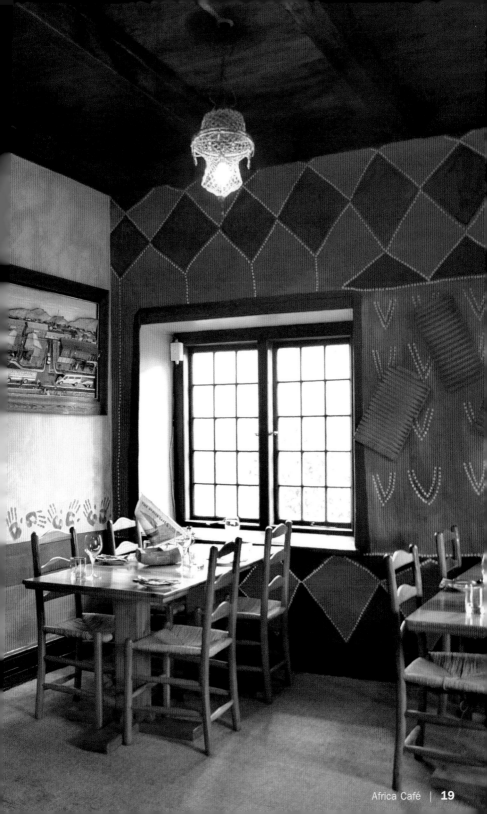

Anatoli

Design: Bevan Christie | Chefs: Mustafa Ciftci, Cenap Maden
Owner: Tayfun Aras

24 Napier Street | Greenpoint, 8005 | Cape Town
Phone: +27 21 419 2501
www.anatoli.co.za
Opening hours: Mon–Sat 7 pm until late (kitchen closes at 11 pm)
Average price: R 68
Cuisine: Traditional Turkish
Special features: Starter, main course or dessert from the tray served at the table

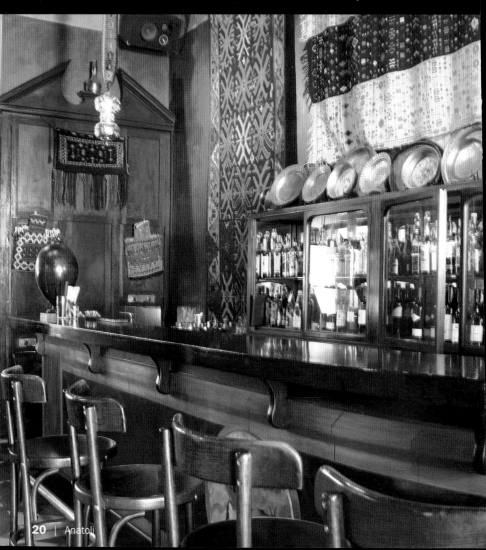

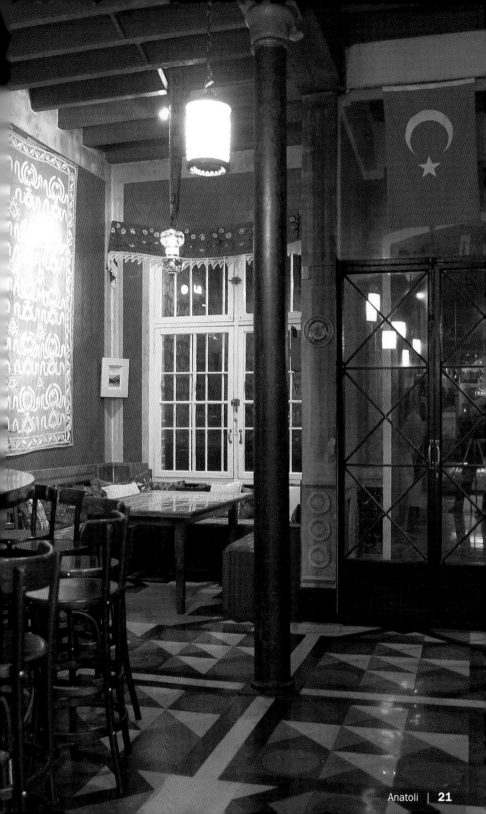

Papaz Yahnisi

Lamb Chops with Bay Leaves and Baby-Onions

Lammkoteletts mit Lorbeer und Babyzwiebeln

Côtelettes d'agneau aux laurier et oignons grelots

Chuletas de cordero con laurel y cebollas baby

Costolette di agnello con alloro e cipolline

16 lamb chops
Salt, pepper
2 tbsp olive oil
150 ml balsamic vinegar
10 bay leaves
8 peppercorns, crushed
Water
1 tsp chili powder
1 tbsp tomato paste
12 baby-onions, peeled
Fragrant rice as side dish

Season the lamb chops with salt and pepper and sear in olive oil on both sides for approx. 3 minutes. Add the balsamic vinegar and stir in the bay leaves and peppercorns. Then reduce until the vinegar is evaporated. Fill up with hot water, so the chops are covered. Simmer for 20 minutes. Stir in the tomato paste, add the onions, season and cook for another 20 minutes. Remove from stove and cool. Serve with fragrant rice.

16 Lammkoteletts
Salz, Pfeffer
2 EL Olivenöl
150 ml Balsamico-Essig
10 Lorbeerblätter
8 Pfefferkörner, zerdrückt
Wasser
1 TL Chilipulver
1 EL Tomatenmark
12 Babyzwiebeln, geschält
Duftreis als Beilage

Die Lammkoteletts salzen, pfeffern und in Olivenöl von beiden Seiten ca. 3 Minuten anbraten. Mit Balsamico-Essig ablöschen und Lorbeerblätter und Pfefferkörner unterrühren. Reduzieren bis der Essig verdampft ist, dann mit heißem Wasser auffüllen, sodass die Koteletts bedeckt sind und 20 Minuten köcheln lassen. Das Tomatenmark einrühren, die Zwiebeln zugeben, würzen und weitere 20 Minuten köcheln lassen. Vom Herd nehmen und etwas abkühlen lassen. Mit Duftreis servieren.

16 côtelettes d'agneau
Sel, poivre
2 c. à soupe d'huile d'olive
150 ml de vinaigre balsamique
10 feuilles de laurier
8 grains de poivre écrasés
Eau
1 c. à café de poudre de piment
1 c. à soupe de concentré de tomates
12 oignons grelots épluchés
Riz parfumé en accompagnement

Saler, poivrer et faire dorer dans l'huile d'olive les côtelettes d'agneau des deux côtés env. 3 minutes. Déglacer au vinaigre balsamique et ajouter les feuilles de laurier et le poivre écrasé. Laisser réduire jusqu'à évaporation du vinaigre, rajouter de l'eau chaude de façon à couvrir les côtelettes et laisser mijoter 20 minutes. Délayer le concentré de tomates, ajouter les oignons, assaisonner et laisser mijoter encore 20 minutes. Retirer du feu et laisser refroidir un instant. Servir avec un riz parfumé.

16 chuletas de cordero
Sal, pimienta
2 cucharadas de aceite de oliva
150 ml de vinagre balsámico
10 hojas de laurel
8 granos de pimienta, machacados
Agua
1 cucharadita de guindilla molida
1 cucharada de concentrado de tomate
12 cebollas baby, peladas
Arroz aromático como acompañamiento

Sazone las chuletas de cordero con sal y pimienta y fríalas durante aprox. 3 minutos en aceite de oliva. Corte la cocción con el vinagre balsámico y añada las hojas de laurel y los granos de pimienta. Deje que hierva hasta que el vinagre se haya evaporado y añada después agua hasta que las chuletas estén cubiertas. Deje que cueza a fuego lento durante 20 minutos. Diluya dentro el concentrado de tomate, incorpore las cebollas, sazone y deje que siga hirviendo a fuego lento durante 20 minutos más. Retire la sartén del fuego y deje que se enfríe un poco. Sirva con arroz aromático.

16 costolette di agnello
Sale, pepe
2 cucchiai di olio d'oliva
150 ml di aceto balsamico
10 foglie di alloro
8 grani di pepe pestati
Acqua
1 cucchiaino di peperoncino in polvere
1 cucchiaio di concentrato di pomodoro
12 cipolline sbucciate
Riso aromatico come contorno

Salare e pepare le costolette di agnello e rosolarle da entrambi i lati in olio d'oliva per circa 3 minuti. Bagnarle con l'aceto balsamico ed incorporarvi le foglie di alloro ed i grani di pepe. Lasciar restringere finché l'aceto è evaporato, quindi allungare con acqua calda in modo da coprire le cotolette e cuocere a fuoco lento per 20 minuti. Amalgamarvi il concentrato di pomodoro, aggiungere le cipolline, condire e cuocere a fiamma bassa per altri 20 minuti. Togliere dal fuoco e lasciar raffreddare un poco. Servire con riso aromatico.

Baía Seafood Restaurant

Chefs, Owners: Luís Viana, Darly Mendelshon

6262 Victoria Wharf | V&A Waterfront, 8002 | Cape Town
Phone: +27 21 421 0935
baiarestaurant@nol.co.za
Opening hours: Mon–Sun noon to 3 pm, 6:45 pm to 11 pm
Average price: R 150 (seafood according market price)
Cuisine: Continental seafood

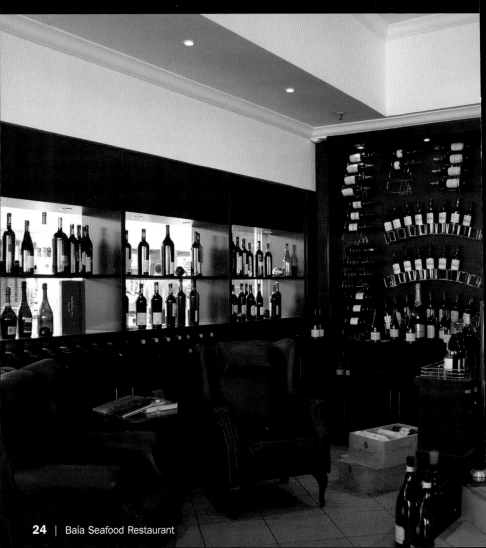

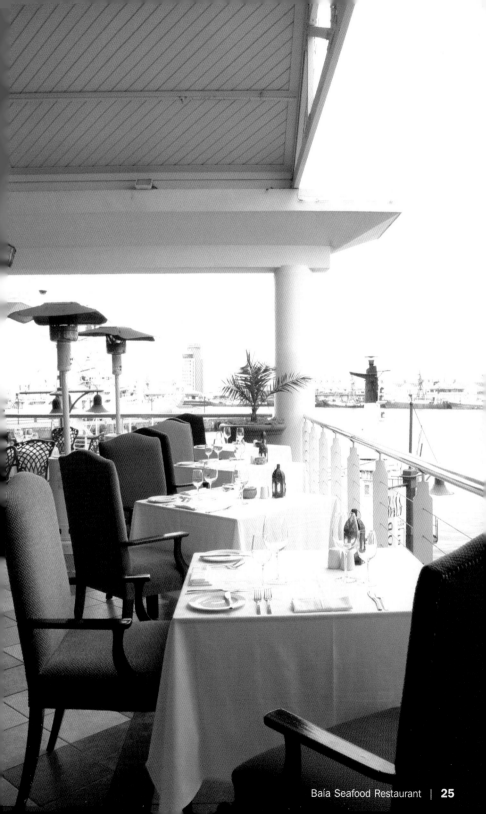

Cataplana
Seafood Stew

Meeresfrüchteeintopf
Pot-au-feu de fruits de mer
Potaje de marisco
Zuppa di frutti di mare

2 carrots, peeled and diced
1 small celeriac, peeled and diced
4 tomatoes, skinned and diced
600 ml vegetable broth
Salt, pepper

20 mussels, cleaned
12 scampi, cleaned
10 1/2 oz firm fish, cut in cubes
120 ml red wine
60 ml Porto

Parsley for decoration

Boil the vegetables in the vegetable broth until soft, season and mash. Let the seafood simmer in the vegetable sauce for 7 minutes. Fill pan with red wine and Porto, and season. Divide the seafood stew onto four deep plates, garnish with a few parsley leaves and serve.

2 Karotten, geschält und gewürfelt
1 kleiner Knollensellerie, geschält und gewürfelt
4 Tomaten, gehäutet und gewürfelt
600 ml Gemüsebrühe
Salz, Pfeffer

20 Miesmuscheln, geputzt
12 Scampi, geputzt
300 g fester Fisch, in Würfel geschnitten
120 ml Rotwein
60 ml Portwein

Petersilie zur Dekoration

Das Gemüse in der Gemüsebrühe weich kochen, abschmecken und alles zusammen pürieren. Die Meeresfrüchte in der Gemüsesauce 7 Minuten gar ziehen lassen. Mit Rotwein und Portwein aufgießen und abschmecken. Den Meeresfrüchteeintopf auf vier tiefe Teller verteilen und mit einigen Blättchen Petersilie garniert servieren.

2 carottes épluchées en dés
1 petit céleri-rave épluché en dés
4 tomates pelées en dés
600 ml de bouillon de légumes
Sel, poivre

20 moules nettoyées
12 scampis nettoyés
300 g de poisson ferme coupé en cubes
120 ml de vin rouge
60 ml de porto

Persil pour la décoration

Faire cuire à cœur les légumes dans le bouillon de légumes, assaisonner et réduire le tout en purée. Faire cuire les fruits de mer dans la sauce de légumes pendant 7 minutes. Mouiller avec le vin rouge et le porto et assaisonner. Répartir le pot-au-feu de fruits de mer dans quatre assiettes creuses et décorer de feuilles de persil avant de servir.

2 zanahorias, peladas y en dados
1 apio nabo pequeño, pelado y en dados
4 tomates, pelados y en dados
600 ml de caldo de verdura
Sal, pimienta

20 mejillones, limpios
12 langostinos, limpios
300 g de pescado de carne firme, cortado en dados 120 ml de vino tinto
60 ml de oporto

Perejil para decorar

Cueza la verdura en el caldo de verdura hasta que esté tierna, sazónela al gusto y hágala puré junto con el caldo. Introduzca el marisco en el puré y déjelo reposar durante 7 minutos hasta que esté en su punto. Añada el vino tinto y el oporto y sazone al gusto. Reparta el guiso en cuatro platos hondos y antes de servir adorne con algunas hojas de perejil.

2 carote sbucciate e tagliate a dadini
1 sedano rapa piccolo sbucciato e tagliato a dadini
4 pomodori spellati e spezzettati
600 ml di brodo vegetale
Sale, pepe

20 cozze pulite
12 scampi puliti
300 g di pesce dalla carne soda, tagliato a dadini
120 ml di vino rosso
60 ml di vino Porto

Per la guarnizione: prezzemolo

Far appassire le verdure nel brodo vegetale, assaggiare, regolare di sale e passare tutto col passaverdure. Lasciar cuocere i frutti di mare nel passato di verdure per 7 minuti. Coprire con vino rosso e con Porto, assaggiare e regolare il condimento. Ripartire la zuppa in quattro piatti fondi e servirla guarnita con foglioline di prezzemolo.

barmooda

Design: Bomax | Chef: Wilfred Thomas | Owner: Reon Heckrath

86 Lower Main Road | Oberservatory, 7935 | Cape Town
Phone: +27 21 447 6752
www.barmooda.co.za
Opening hours: Mon–Sat 10 am to 2 am
Average price: R 40
Cuisine: Fusion of Asian and Western, sushi

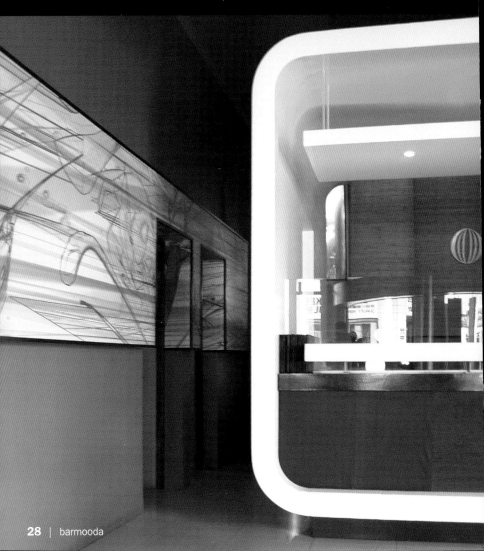

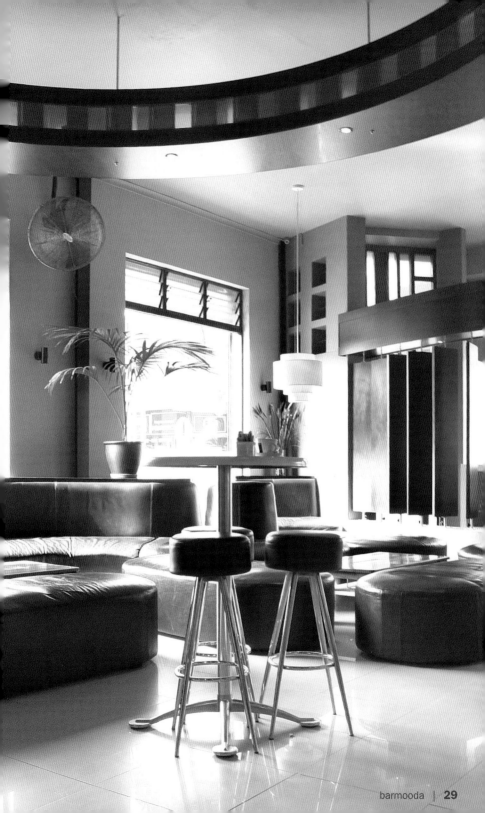

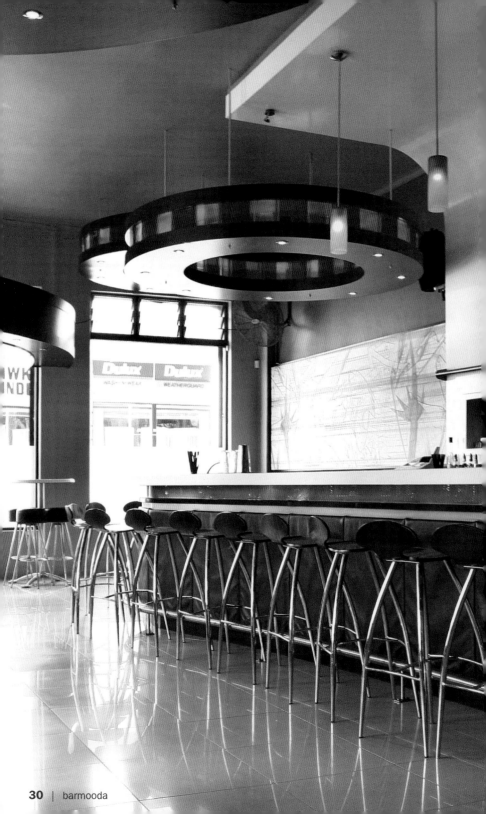

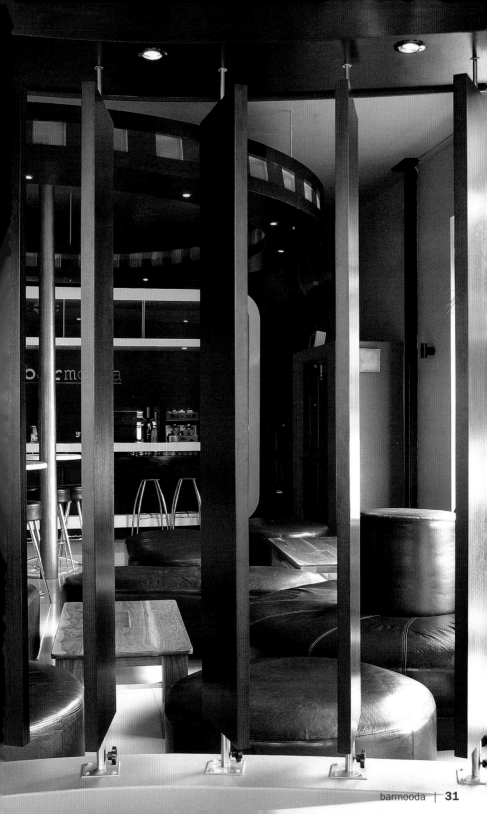

Beluga

Design: Leon Saven | Chef: Andy Lee | Owners: Rudi Minaar, Hugh von Zahn

The Foundry, Prestwich Street | Greenpoint, 8001 | Cape Town
Phone: +27 21 418 2948
www.beluga.co.za
Opening hours: Mon–Sun 9 am to 5:30 pm, 6:30 pm to 11 pm
Average price: R 90
Cuisine: Cosmopolitan
Special features: Wine attic, cigar lounge

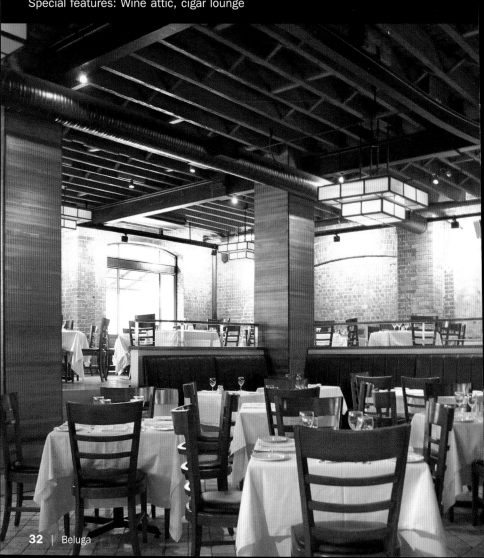

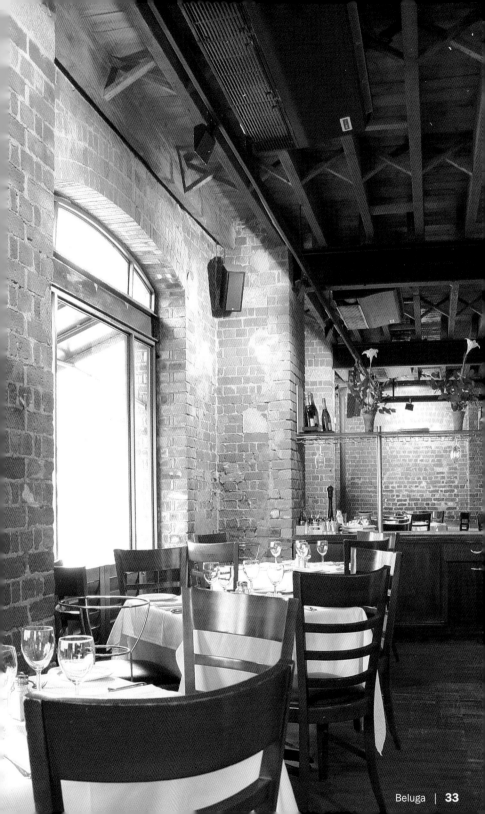

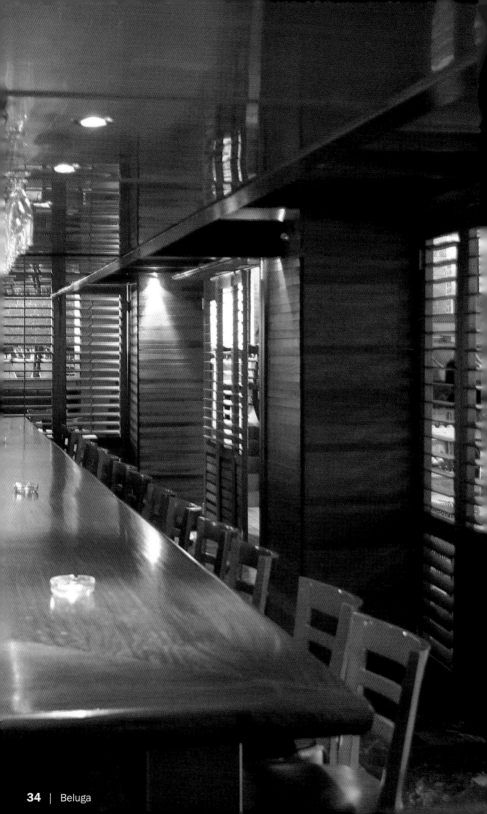

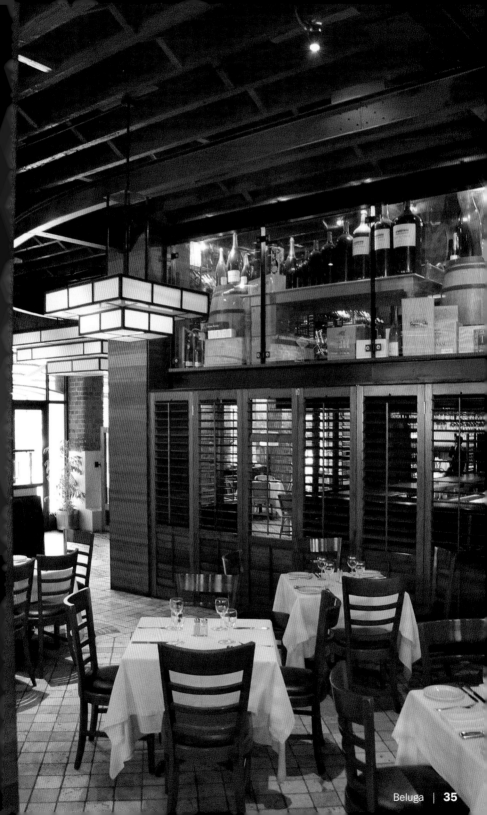

Buena Vista Social Cafe

Design, Owners: George Contogiannis & Giorgos Karipidis
Chef: George Steyn

1st Floor Exhibition Building, 81 Main Road | Greenpoint, 8001 | Cape Town
Phone: +27 21 433 0611
www.buenavista.co.za
Opening hours: Mon–Sun noon to 2 am
Average price: R 45
Cuisine: Cuban
Special features: Sun from 9 pm Salsa Fuego, Mon from 9 pm live band "Cha Cha Cha"

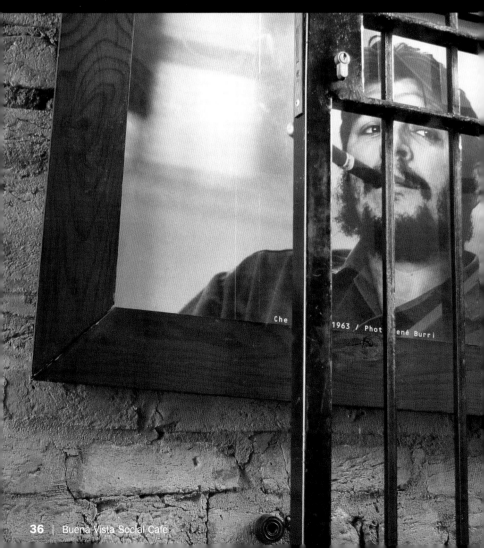

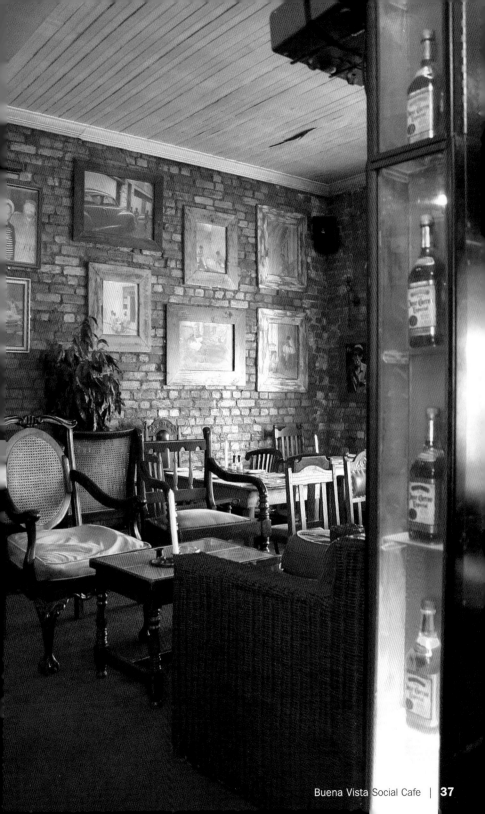

Bukhara

Design: Sabi & Elana Sabharwal | Chef: Murti Singh
Owner: Sabi Sabharwal

33 Church Street | City Centre, 8001 | Cape Town
Phone: +27 21 424 0000
www.bukhara.com
Opening hours: Lunch Mon–Sat noon to 4 pm, dinner Mon–Sun 6 pm to 11 pm
Average price: R 75
Cuisine: Northern Indian
Special features: North Indian Tandoori (charcoal fired clay ovens), Singri (open flame grill) and Tawa (flat iron grill) styles of cooking

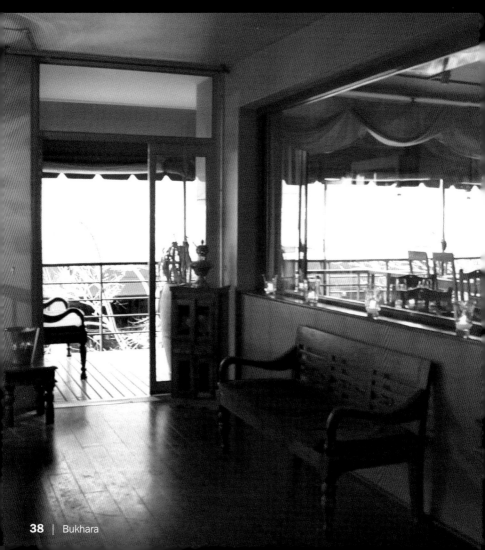

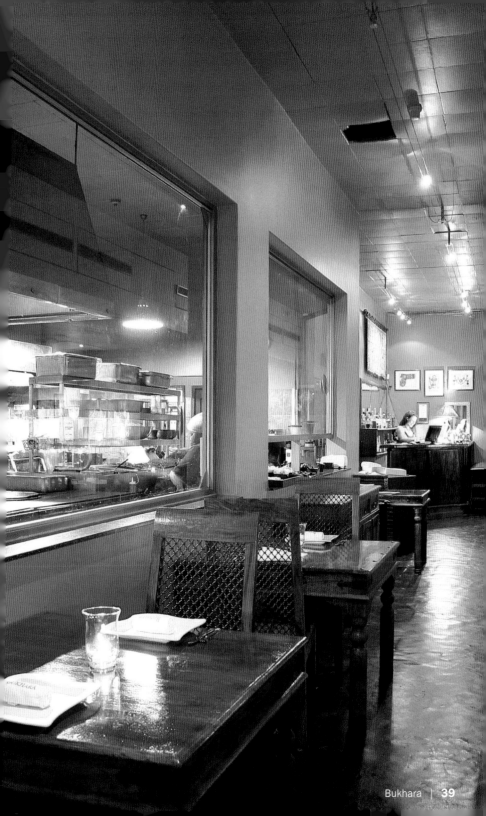

Marinated Lamb Chops

Marinierte Lammkoteletts

Côtelettes d'agneau marinées

Chuletas marinadas de cordero

Costolette di agnello marinate

8 lamb chops
1/2 ripe pawpaw (papaya type)
120 ml vinegar
2 tbsp garlic, chopped
2 tbsp ginger, chopped
2 tbsp green chili paste
2 tbsp red chili paste
500 ml yoghurt
1 tbsp Garam Masala (spice mix)
1 egg
100 ml sunflower oil
Salt
Parsley and lemon wedges for decoration

Mash the pawpaw with vinegar and season with salt. Marinade the lamb chops in the mixture at room temperature. After one hour, remove the meat from the marinade. Rub meat with garlic, ginger and both chili pastes. Mix yoghurt, Garam Masala, egg and oil together and pour over the chops. Marinade in the refrigerator for at least 12 hours.
Barbecue prepared lamb chops in a covered grill (not over open flame) for approx. 10 minutes.
Arrange on preheated plates and garnish with parsley and lemon wedges.

8 Lammkoteletts
1/2 reife Pawpaw (Papayasorte)
120 ml Essig
2 EL Knoblauch, gehackt
2 EL Ingwer
2 EL grüne Chilipaste
2 EL rote Chilipaste
500 ml Joghurt
1 EL Garam Masala (Gewürzmischung)
1 Ei
100 ml Sonnenblumenöl
Salz
Petersilie und Zitronenspalten zur Dekoration

Die Pawpaw mit dem Essig pürieren und mit Salz abschmecken. Die Lammkoteletts 1 Stunde bei Zimmertemperatur in dieser Mischung marinieren. Danach das Fleisch aus der Marinade nehmen und mit dem Knoblauch, Ingwer und den beiden Chilipasten bestreichen. Den Joghurt mit Garam Masala, dem Ei und dem Öl mischen und über die Koteletts geben. Für mindestens 12 Stunden im Kühlschrank marinieren.
Abschließend die Lammkoteletts in einem geschlossenen Grill, aber nicht auf offener Flamme, ca. 10 Minuten garen.
Auf vorgewärmten Tellern anrichten und mit Zitronenspalten und Petersilie garnieren.

8 côtelettes d'agneau
1/2 pawpaw mûre (sorte de papaye)
120 ml de vinaigre
2 c. à soupe d'ail haché
2 c. à soupe de gingembre
2 c. à soupe de pâte de piment vert
2 c. à soupe de pâte de piment rouge
500 ml de yaourt
1 c. à soupe de garam masala (mélange d'épices)
1 œuf
100 ml d'huile de tournesol
Sel
Persil et quartiers de citron pour la décoration

Réduire en purée la papaye avec le vinaigre et saler. Faire mariner les côtelettes d'agneau à température ambiante pendant 1 h dans ce mélange. Retirer ensuite de la marinade et badigeonner la viande d'ail, de gingembre et des deux pâtes de piment. Mélanger le yaourt avec le garam masala, l'œuf et l'huile et verser sur les côtelettes. Laisser mariner au réfrigérateur pendant au moins 12 heures.
Faire cuire ensuite les côtelettes dans un grill fermé, mais pas sur la flamme ouverte, pendant env. 10 minutes.
Dresser sur des assiettes préchauffées et garnir de persil et de quartiers de citron.

8 chuletas de cordero
1/2 pawpaw madura (un tipo de papaya)
120 ml de vinagre
2 cucharadas de ajo, picado
2 cucharadas de jengibre
2 cucharadas de pasta de guindilla verde
2 cucharadas de pasta de guindilla roja
500 ml de yogur
1 cucharada de Garam Masala (mezcla de especias)
1 huevo
100 ml de aceite de girasol
Sal
Perejil y rodajas de limón para decorar

Haga puré la pawpaw junto con el vinagre y sazone con la sal. Marine las chuletas de cordero en esta mezcla durante 1 hora a temperatura ambiente. Saque después la carne de la marinada y frótela con el ajo, el jengibre y las dos pastas de guindilla. Mezcle el yogur con la Garam Masala, el huevo y el aceite y vierta la mezcla por encima de las chuletas. Deje marinar la carne en el frigorífico durante 12 horas como mínimo.
Coloque después las chuletas de cordero en una parrilla cerrada, pero no sobre llama abierta, y áselas durante aprox. 10 minutos.
Coloque la carne en platos precalentados y adorne con las rodajas de limón y el perejil.

8 costolette di agnello
1/2 pawpaw matura (tipo di papaya)
120 ml di aceto
2 cucchiai di aglio tritato
2 cucchiai di zenzero
2 cucchiai di pasta di peperoncino verde
2 cucchiai di pasta di peperoncino rosso
500 ml di yogurt
1 cucchiaio di Garam Masala (misto di aromi)
1 uovo
100 ml di olio di semi di girasole
Sale
Per la guarnizione: prezzemolo e spicchi di limone

Passare col passaverdure la pawpaw con l'aceto e salarla. Marinarvi a temperatura ambiente per 1 ora le costolette di agnello. Successivamente, estrarre la carne dalla marinata e cospargerla con l'aglio, lo zenzero e le paste di peperoncino. Mescolare lo yogurt con il Garam Masala e l'uovo con l'olio, e versare il tutto sulle costolette. Marinare in frigorifero per 12 ore.
Fare quindi cuocere le costolette in un grill chiuso, ma non a fuoco diretto, per circa 10 minuti. Servire su piatti caldi e guarnire con spicchi di limone e prezzemolo.

Cara Lazuli

Design, Owner: Richard Griffin | Chef: Ryan Berry

13 Buiten Street | City Centre, 8001 | Cape Town
Phone: +27 21 426 2351
www.zingara.co.za
Opening hours: Mon–Sat 7 pm onwards
Average price: R 65
Cuisine: Contemporary Moroccan

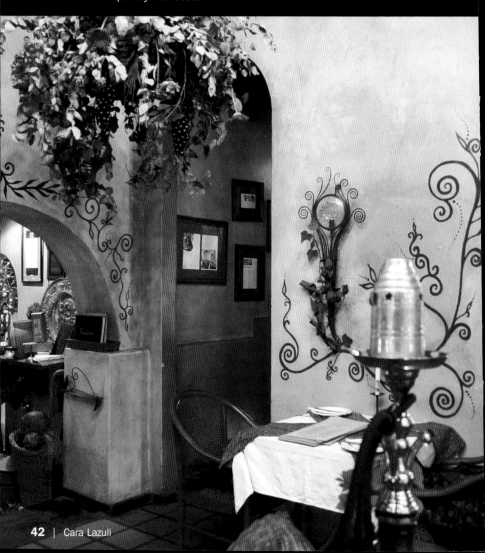

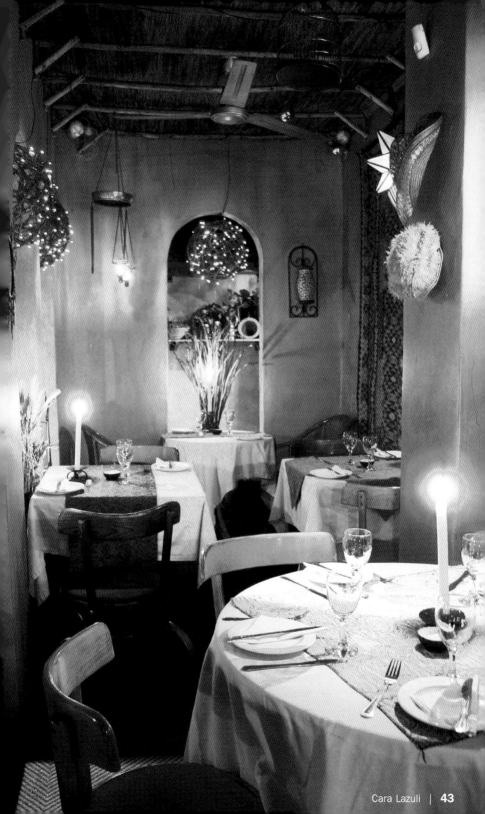

Stuffed Eggplant Rolls

Gefüllte Auberginenröllchen

Rouleaux d'aubergine farcis

Rollitos de berenjena rellenos

Involtini di melanzane ripieni

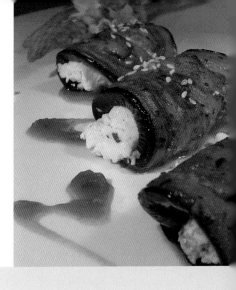

1 eggplant
Salt
3 tbsp olive oil
1 roll fresh goat cheese (7 oz)
7 oz ricotta cheese
1 tbsp parsley, chopped
2 tbsp dried tomatoes, diced
2 tbsp pine nuts, roasted and chopped
Salt, pepper
200 ml Napolitana Sauce (e.g. Woolworth)
2 tbsp sesame seeds, roasted

Cut the eggplant into 0.1 inch thick slices lengthwise, sprinkle with salt on both sides and set aside for 20 minutes. In the meantime mix the fresh goat cheese, ricotta cheese, parsley, dried tomatoes and pine nuts together and season. Tab the eggplant slices dry, rub with olive oil and brown lightly in a 390 °F oven. Spread the cheese mixture on the eggplant slices, shape into small rolls and bake for another 10 minutes in the oven. Heat the Napolitana sauce, divide onto four plates, place the rolls on the sauce and sprinkle with sesame seeds.

1 Aubergine
Salz
3 EL Olivenöl
1 Rolle Ziegenfrischkäse (200 g)
200 g Ricotta
1 EL Petersilie, gehackt
2 EL getrocknete Tomaten, gewürfelt
2 EL Pinienkerne, geröstet und gehackt
Salz, Pfeffer
200 ml Neapolitanische Sauce (z.B. Woolworth)
2 EL Sesam, geröstet

Die Aubergine in 3 mm dünne Scheiben schneiden, von beiden Seiten salzen und 20 Minuten ruhen lassen. In der Zwischenzeit den Ziegenfrischkäse mit dem Ricotta, der Petersilie, den getrockneten Tomaten und den Pinienkernen mischen und abschmecken. Die Auberginenscheiben trockentupfen, mit Olivenöl einreiben und bei 200 °C im Backofen leicht bräunen. Mit der Käsemischung bestreichen, zu kleinen Rollen formen und weitere 10 Minuten im Ofen überbacken. Die Sauce erhitzen, auf vier Teller verteilen, die Röllchen auf die Sauce legen und mit Sesam bestreuen.

. aubergine
Sel
3 c. à soupe d'huile d'olive
1 rouleau de fromage de chèvre frais (200 g)
200 g de ricotta
1 c. à soupe de persil haché
2 c. à soupe de tomates séchées en dés
2 c. à soupe de pignons grillés et hachés
Sel, poivre
200 ml de sauce napolitaine (par ex. Woolworth)
2 c. à soupe de graines de sésame grillées

Couper l'aubergine en fines tranches de 3 mm, saler des deux côtés et laisser reposer 20 minutes. Entre-temps mélanger le fromage de chèvre frais avec le ricotta, le persil, les tomates séchées et les pignons et assaisonner. Sécher les aubergines avec d'essuie-tout, badigeonner d'huile d'olive et faire dorer légèrement au four à 200 °C. Tartiner avec le mélange de fromage, former de petits rouleaux et cuire au four encore 10 minutes. Réchauffer la sauce, la répartir sur quatre assiettes, y déposer les rouleaux et parsemer de graines de sésame.

1 berenjena
Sal
3 cucharadas de aceite de oliva
1 barra de queso fresco de cabra (200 g)
200 g de ricota
1 cucharada de perejil, picado
2 cucharadas de tomates secos, en dados
2 cucharadas de piñones, tostados y picados
Sal, pimienta
200 ml de salsa napolitana (p.ej. Woolworth)
2 cucharadas de semillas de sésamo, tostadas

Corte la berenjena en lonchas de 3 mm de grosor, sazónelas con sal por ambos lados y déjelas reposar durante 20 minutos. En ese tiempo mezcle el queso de cabra con la ricota, el perejil, los tomates secos y los piñones y sazone. Seque las lonchas de berenjena presionando brevemente con un papel de cocina, píntelas con aceite de oliva y áselas en el horno a 200 °C hasta que se doren ligeramente. Úntelas después con la mezcla del queso, forme pequeños rollitos y áselas durante 10 minutos más en el horno. Caliente la salsa, repártala en cuatro platos, coloque sobre ella los rollitos y esparza por encima las semillas de sésamo.

1 melanzana
Sale
3 cucchiai di olio d'oliva
200 g di formaggio caprino fresco
200 g di ricotta
1 cucchiaio di prezzemolo tritato
2 cucchiai di pomodori secchi tagliati a pezzetti
2 cucchiai di pinoli tostati e tritati
Sale, pepe
200 ml di salsa napoletana (ad es. Woolworth)
2 cucchiai di sesamo tostato

Tagliare la melanzana a fette dello spessore di 3 mm, salarle da entrambe le parti e lasciarle riposare per 20 minuti. Nel frattempo, mescolare il caprino con la ricotta, il prezzemolo, i pomodori secchi ed i pinoli. Assaggiare e regolare il condimento. Asciugare le fette di melanzana, strofinarle con olio d'oliva e dorarle in forno a 200 °C. Spalmarle con l'impasto di formaggio, formare degli involtini e gratinare nel forno per altri 10 minuti. Riscaldare la salsa, ripartirla in quattro piatti, adagiarvi gli involtini e cospargere di sesamo.

Ginja

Design: Catherine Wright Interiors | Chef: Michael Bassett
Owners: Michael Bassett & Gary Wright

121 Castle Street | City Centre, 8001 | Cape Town
Phone: +27 21 426 2368
passionfood@iafrica.com
Opening hours: Mon–Sat 7 pm to 10 pm
Average price: R 200 (three course menu)
Cuisine: Fusion

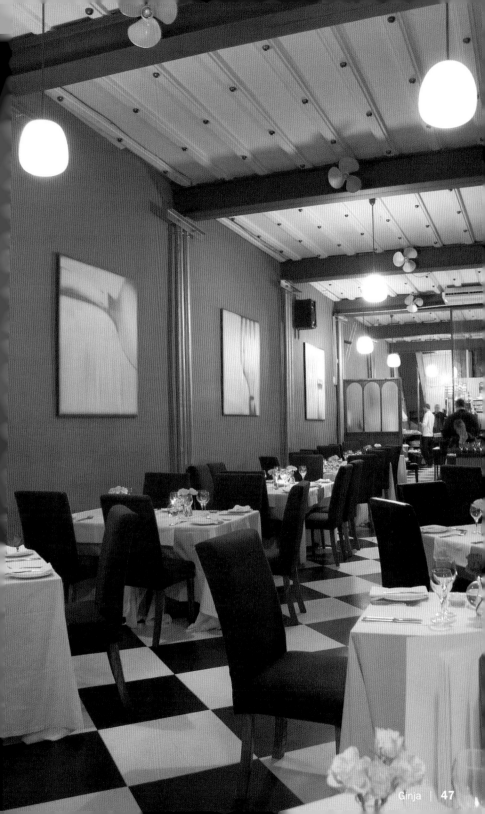

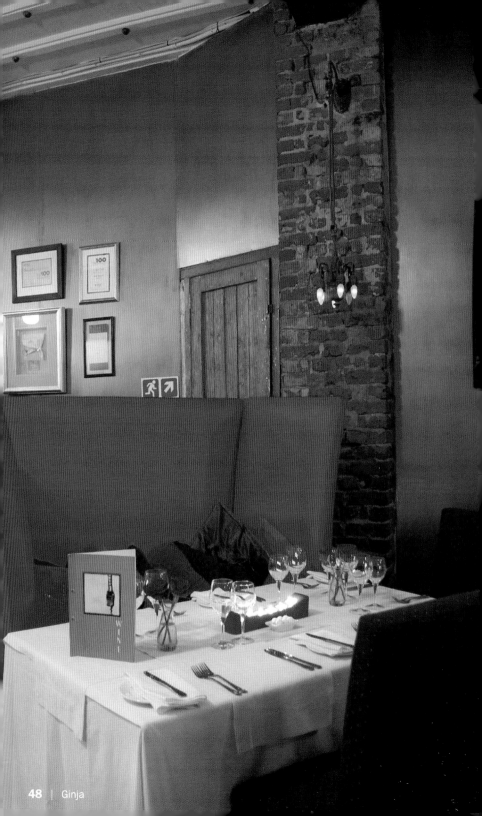

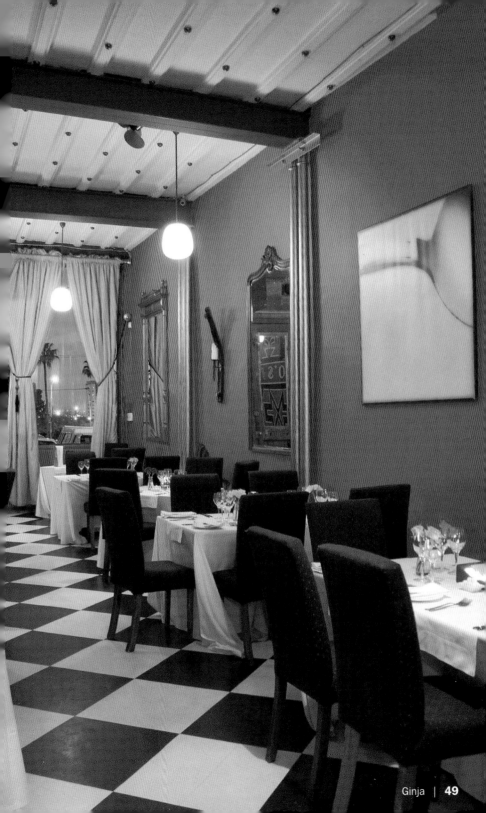

Strawberries and Cream

Erdbeeren und Sahne

Fraises et crème

Fresas y nata

Fragole e panna

Warm up a 1 lb 8 1/2 oz strawberries, 200 ml water and 5 1/3 oz sugar in a pot covered with plastic foil. Set aside for 1 hour. Strain entire mixture and reserve juice in another container. Mash the strawberries and chill.

Chill 1/3 of the strawberry juice in the refrigerator. Heat the remaining 2/3 strawberry water with 1 tsp rosemary needles and dissolve 3 leaves of soaked and squeezed gelatin in the liquid. Pour the liquid through a strainer and fill into four small cone-shaped containers. Chill.

Heat 180 ml milk, but do not boil. Stir in 2 egg yolks and whisk until the liquid thickens. Chill and combine with 4 tbsp mashed strawberries and 8 1/2 oz very stiff beaten egg whites. Fill into four shallow containers and chill.

Reduce 100 ml water and 5 1/3 oz sugar until syrupy (approx. 7 minutes). Whip 5 large egg yolks until they are light yellow and very creamy, add the sugar syrup gradually, while stirring constantly. Whip 1 lb 1 1/2 oz cream and fold under the mixture. Then separate in two bowls.
Mix one half with 2 tbsp mashed strawberries, the other half with 4 tbsp white melted chocolate. Fill four spherical containers with one mixture and freeze. Then fill up with the second mixture and freeze in order to get two separate layers.

Distribute 400 ml champagne with the leftover 1/3 of the strawberry water into four glasses.

700 g Erdbeeren, 200 ml Wasser und 150 g Zucker in einen Topf geben, mit Klarsichtfolie bedecken und erwärmen. 1 Stunde ziehen lassen, dann abseihen und den Saft auffangen. Die Erdbeeren pürieren und kalt stellen.

1/3 des Erdbeerwassers kalt stellen. Die übrigen 2/3 Erdbeerwasser mit 1 TL Rosmarinnadeln erhitzen und 3 Blatt eingeweichte und ausgedrückt Gelatine darin auflösen. Die Flüssigkeit durch ein Sieb gießen und in vier kegelförmige Förmchen füllen. Kalt stellen.

180 ml Milch erhitzen, aber nicht kochen. Zwei Eigelb einrühren und schlagen bis sich Flüssigkeit eindickt. Abkühlen und anschließend 4 EL Erdbeerpüree und 240 g sehr steif geschlagenen Eischnee unterheben. In vier flache Formen füllen. Kalt stellen.

100 ml Wasser und 150 g Zucker zu einem Sirup einkochen (ca. 7 Minuten). 5 große Eigelb so lange schlagen bis sie hellgelb und sehr cremig sind, dann nach und nach den Zuckersirup zugeben, dabei ständig weiterrühren. 500 g Sahne schlagen und unter die Masse heben.
In die eine Hälfte 2 EL Erdbeerpüree, in die andere Hälfte 4 EL weiße, geschmolzen Schokolade einrühren. Vier runde Bombenformen mit einer der beiden Masse füllen und einfrieren. Dann die zweite Masse auffüllen und erneut einfrieren, um zwei Lagen zu erhalten.

400 ml Champagner mit dem verbliebenen 1/3 Erdbeerwasser mischen und in Gläser füllen.

Mettre 700 g de fraises, 200 ml d'eau et 150 g de sucre dans une casserole, couvrir d'une feuille de plastique alimentaire et réchauffer. Laisser macérer une heure, filtrer et récupérer le jus. Réduire les fraises en purée et mettre au frais.

Mettre 1/3 du jus de fraises au frais. Réchauffer les 2/3 du jus de fraises restants avec 1 c. à café de brins de romarin et y délayer 3 feuilles de gélatine détrempées et pressées. Passer ce liquide au chinois et répartir dans des moules coniques. Mettre au frais.

Réchauffer 180 ml de lait, délayer 2 jaunes d'œuf et remuer jusqu'à ce que le liquide épaississe. Laisser refroidir et mélanger ensuite avec 4 c. à soupe de purée de fraises et 240 g de blancs d'œuf battus en neige très ferme. Verser dans quatre moules plats et mettre au frais.

Cuire un sirop avec 100 ml d'eau et 150 g de sucre (env. 7 minutes). Battre 5 gros jaunes d'œuf jusqu'à ce qu'ils deviennent jaune clair et très mousseux, y ajouter peu à peu le sirop de sucre sans cesser de remuer. Monter 500 g de crème en chantilly, incorporer à l'appareil et répartir à égalité dans deux jattes.
Dans l'une, délayer 2 c. à soupe de purée de fraises, dans l'autre 4 c. à soupe de chocolat blanc fondu. Verser l'une des deux préparations dans quatre moules en forme de boule et congeler. Compléter ensuite avec la deuxième préparation et congeler pour obtenir deux couches.

Mélanger 400 ml de champagne avec le 1/3 de jus de fraises restant et remplir des verres.

Ponga 700 g de fresas, 200 ml de agua y 150 g de azúcar en un cazo, cúbralo con film transparente y caliéntelo. Deje que repose una hora, pase la mezcla por el colador y reserve el líquido. Haga puré las fresas y póngalas en el frigorífico.

Reserve 1/3 del líquido de las fresas en frío. Caliente los 2/3 del líquido de las fresas restante con 1 cucharadita de hojas de romero y diluya dentro 3 láminas de gelatina previamente reblandecidas y escurridas. Cuele el líquido y repártalo en cuatro moldes pequeños con forma de cono. Resérvelos en el frigorífico.

Caliente 180 ml de leche. Añada 2 yemas y bata hasta que el líquido se espese. Deje enfriar la mezcla, incorpore 4 cucharadas del puré de fresa y 240 g de clara a punto de nieve y remueva. Rellene 4 moldes llanos y póngalos en el frigorífico.

Cueza 100 ml de agua con 150 g de azúcar hasta que se forme un jarabe (aprox. 7 minutos). Bata 5 yemas hasta que la masa tenga un color amarillo claro y una consistencia muy cremosa. Añádala después poco a poco al jarabe de azúcar sin dejar de remover. Bata 500 g de nata, incorpórela a la mezcla de las yemas y reparta la masa en dos cuencos.
Mezcle una de las mitades de la masa con 2 cucharadas de puré de fresa y la otra con 4 cucharadas de chocolate blanco derretido. Rellene cuatro moldes esféricos con una de las masas y póngalos en el congelador. Rellénelos después con la segunda masa y vuelva a ponerlos en el congelador para conseguir dos capas.

Mezcle 400 ml de champaña con el tercio restante del agua de las fresas y vierta el líquido en vasos.

Mettere in una pentola 700 g di fragole, 200 ml d'acqua e 150 g di zucchero, coprire con pellicola trasparente e riscaldare. Far riposare 1 ora, quindi filtrare e raccogliere il succo. Ridurre a purea le fragole e mettere in fresco.

Mettere in fresco 1/3 della loro acqua. Riscaldare i restanti 2/3 con 1 cucchiaino di aghi di rosmarino e scioglIervi 3 fogli di gelatina ammorbidita e strizzata. Passare il liquido al setaccio e versarlo in quattro formine coniche. Mettere in frigo.

Riscaldare 180 ml di latte. Incorporarvi 2 tuorli d'uovo e mescolare finché il liquido si addensa. Lasciar raffreddare e mischiarvi 4 cucchiai di purea di fragole e 240 g di albume d'uovo montato a neve molto densa. Versare il composto in quattro forme basse e mettere in frigo.

Cuocere per circa 7 minuti uno sciroppo con 100 ml d'acqua e 150 g di zucchero. Sbattere 5 grossi tuorli d'uovo finché siano chiari e molto cremosi, quindi incorporarvi poco alla volta lo sciroppo continuando a mescolare. Montare 500 g panna, unirla al composto e ripartire il tutto in due scodelle.
Incorporare in una metà 2 cucchiai di purea di fragole e nell'altra 4 cucchiai di cioccolato bianco sciolto. Versare uno dei due composti in quattro forme sferiche e congelare. Versare e congelare poi il secondo composto, ottenendo così due strati.

Mescolare 400 ml di champagne con il restante succo di fragole e versarlo nei bicchieri.

Greens on Park

Design: Alpha Design | Chefs, Owners: W. B. De Villiers, Mike van der Spuy

5 Park Road | Gardens, 8001 | Cape Town
Phone: +27 21 422 4415
greensonpark@mweb.co.za
Opening hours: Mon 8 am to 5 pm, Tue–Sun 8 am to 11 pm, breakfast served all day
Average price: R 45
Cuisine: Contemporary, wood oven pizza
Special features: Modern city restaurant, sunny alfresco atmosphere

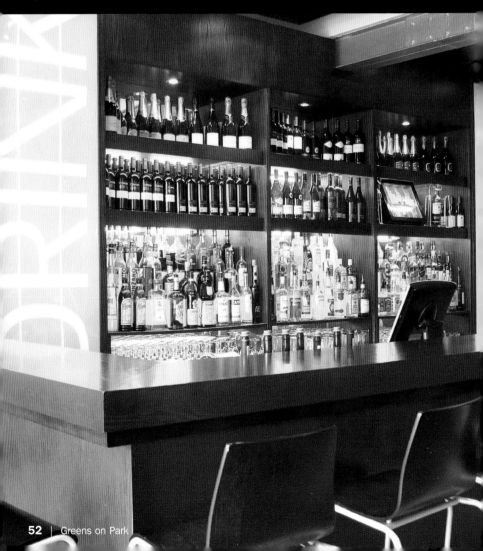

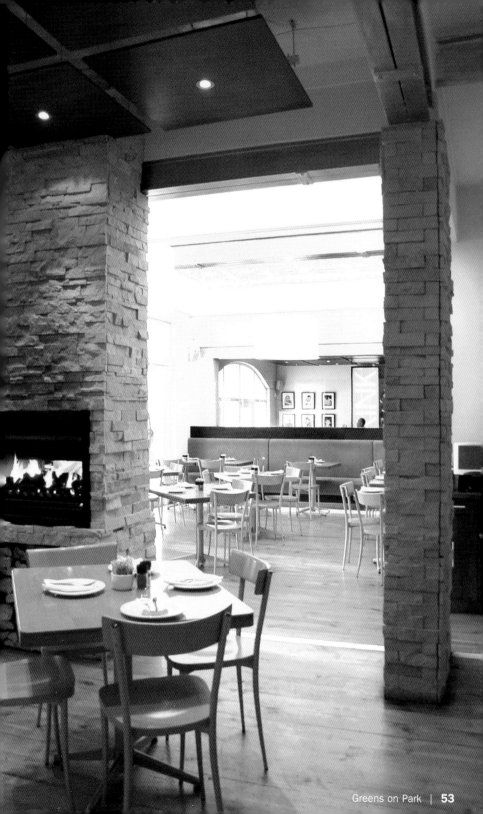

Haiku

Design: Sabi & Elana Sabharwal | Chef: Xinqun Luo
Owner: Sabi Sabharwal

33 Church Street | City Centre, 8001 | Cape Town
Phone: +27 21 424 7000
haiku@bukhara.com
Opening hours: Mon–Fri noon to 3 pm, Mo–Sat 6 pm to 11 pm
Average price: R 180
Cuisine: Asian tapas

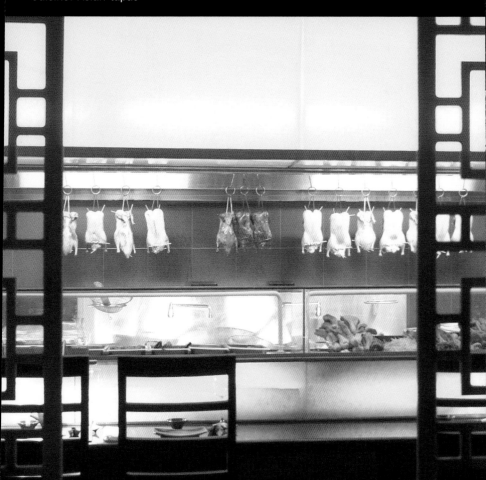

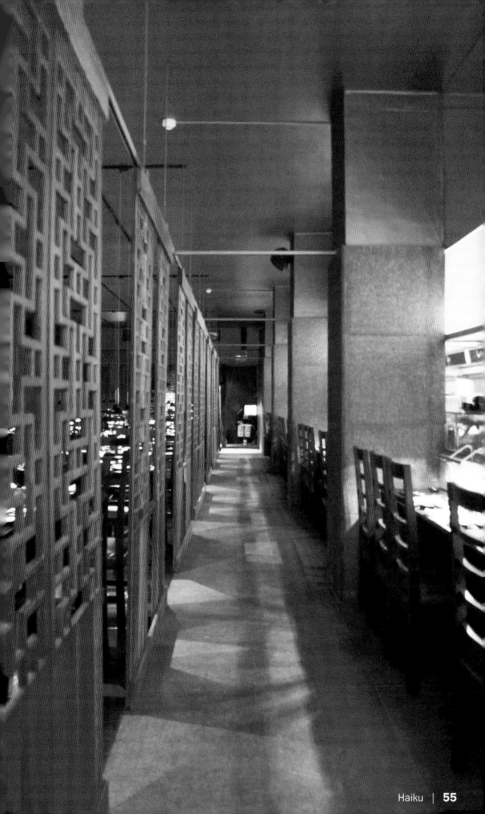

Madame Zingara

Design, Owner: Richard Griffin | Chef: Quintin Petersen

192 Loop Street | City Centre, 8001 | Cape Town
Phone: +27 21 426 2458
www.zingara.co.za
Opening hours: Mon–Sat 7 pm onwards
Average price: R 65
Cuisine: Contemporary Italian
Special features: Bohemian romantic

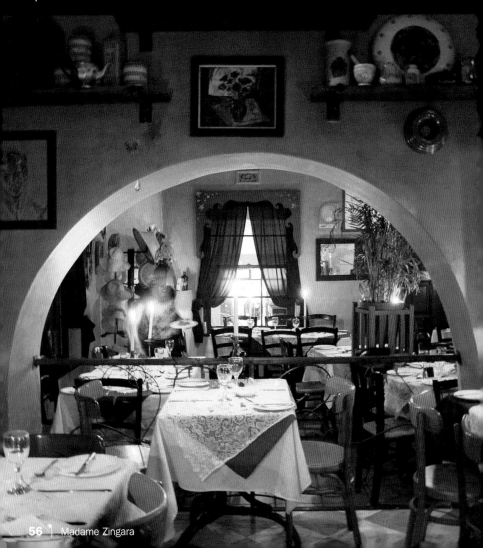

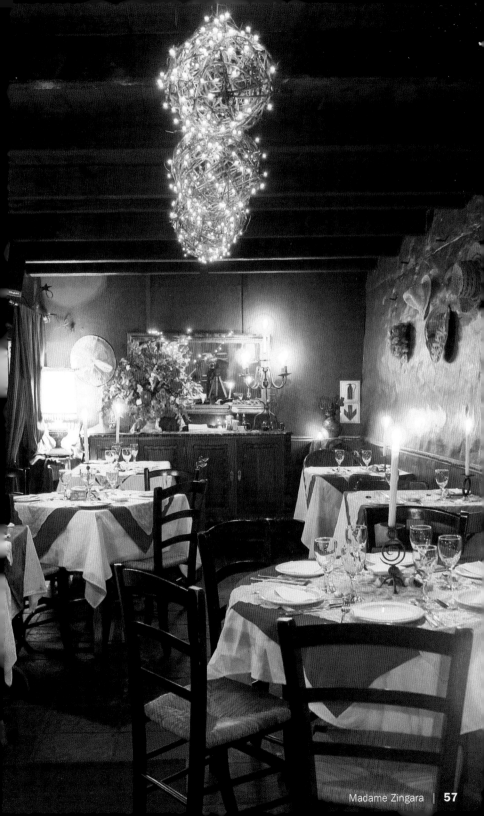

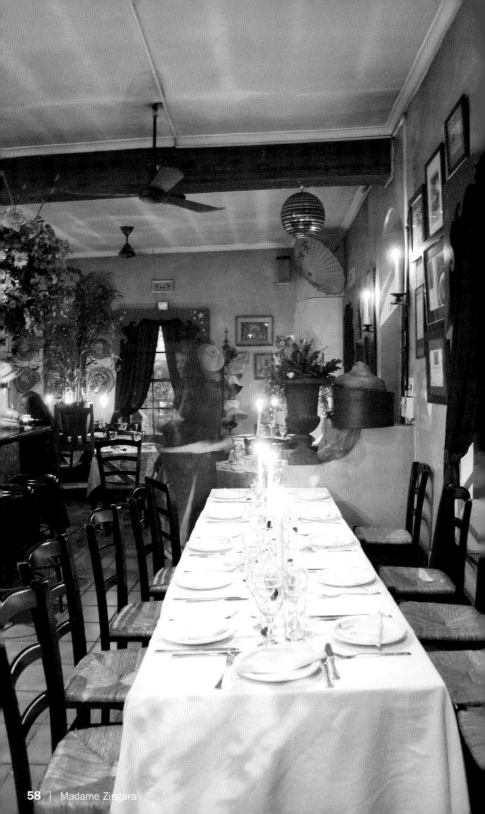

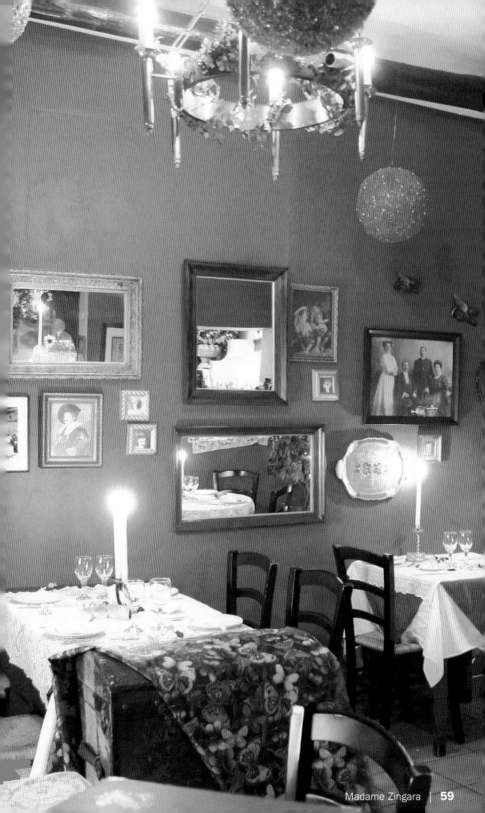

Ravioli

with Gorgonzola and Green Asparagus

Ravioli mit Gorgonzola und grünem Spargel

Raviolis aux gorgonzola et asperge verte

Ravioli con gorgonzola y espárragos verdes

Ravioli con gorgonzola e asparagi verdi

1 lb 1 1/2 oz spinach-ricotta-ravioli (convenience product)
20 stalks green asparagus, approx. 4 inches
2 tbsp butter
2 tbsp olive oil
8 leaves of sage
Salt, pepper
3 1/2 oz Gorgonzola
2 oz pine nuts, roasted

Blanch asparagus until al dente, drain and set aside. Cook the ravioli in salted water until al dente. Heat butter and olive oil in a pan, sauté the sage leaves, add in the asparagus, and season to taste. Toss in the ravioli into the pan and fold in to the legume. Divide onto four plates. Crumble the Gorgonzola and sprinkle pine nuts over the ravioli. Serve immediately.

500 g Spinat-Ricotta-Ravioli (Fertigprodukt)
20 Stangen grünen Spargel, ca. 10 cm lang
2 EL Butter
2 EL Olivenöl
8 Blätter Salbei
Salz, Pfeffer
100 g Gorgonzola
50 g Pinienkerne, geröstet

Den Spargel bissfest blanchieren, abschrecken und beiseite stellen. Die Ravioli in Salzwasser al dente garen. Butter und Olivenöl in einer Pfanne erhitzen, die Salbeiblätter anschwitzen und die Spargelstangen zugeben. Abschmecken. Die Ravioli in die Pfanne geben. Alles miteinander mischen, abschmecken und auf vier Tellern verteilen. Den Gorgonzola zerkrümeln und mit den Pinienkernen über den Ravioli verteilen. Sofort servieren.

500 g de raviolis aux épinards et ricotta (tout rêts)
20 pointes d'asperge verte d'env. 10 cm de long
2 c. à soupe de beurre
2 c. à soupe d'huile d'olive
8 feuilles de sauge
Sel, poivre
100 g de gorgonzola
50 g de pignons grillés

Blanchir les asperges al dente, les passer sous l'eau froide et réserver. Faire cuire les raviolis al dente dans de l'eau salée. Chauffer le beurre et l'huile d'olive dans une poêle, faire fondre les feuilles de sauge et ajouter les pointes d'asperge. Assaisonner. Mettre les raviolis dans la poêle, mélanger le tout, rectifier l'assaisonnement et répartir sur quatre assiettes. Emietter le gorgonzola et répandre avec les pignons sur les raviolis. Servir sans attendre.

500 g de ravioli rellenos con espinacas y ricota (producto preparado)
20 espárragos verdes, aprox. 10 cm de largo
2 cucharadas de mantequilla
2 cucharadas de aceite de oliva
8 hojas de salvia
Sal, pimienta
100 g de queso gorgonzola
50 g piñones, tostados

Escalde los espárragos hasta que estén tiernos, corte después la cocción con agua fría y resérvelos. Cueza los ravioli en agua con sal hasta que estén en su punto. Caliente la mantequilla y el aceite de oliva en una sartén, rehogue dentro las hojas de salvia y añada los espárragos. Incorpore los ravioli. Remueva, sazone al gusto y reparta los ingredientes en cuatro platos. Desmenuce el queso gorgonzola y espárzalo por encima de los ravioli junto con los piñones. Sirva inmediatamente.

500 g di ravioli alla ricotta e spinaci (acquistati pronti)
20 asparagi verdi della lunghezza di circa 10 cm
2 cucchiai di burro
2 cucchiai di olio d'oliva
8 foglie di salvia
Sale, pepe
100 g di gorgonzola
50 g di pinoli tostati

Scottare al dente gli asparagi, passarli sotto l'acqua fredda e metterli da parte. Cuocere al dente i ravioli in acqua salata. Scaldare in una padella il burro e l'olio d'oliva, rosolare le foglie di salvia ed aggiungervi gli asparagi. Assaggiare e regolare il condimento. Versare i ravioli nella padella. Mescolare il tutto, regolare il condimento e disporre i ravioli in quattro piatti. Spezzettare il gorgonzola e ripartirlo sui ravioli insieme ai pinoli. Servire subito.

Manna Epicure

Design, Owners: Hennie Andrews, Maranda Engelbrecht, Jacques Erasmus | Chef: Jacques Erasmus

151 Kloof Street | Tamboerskloof, 8001 | Cape Town
Phone: +27 21 426 2413
mannaepicure@mweb.co.za
Opening hours: Tue–Sat 8 am to 8 pm, Sun 8 am to 4 pm
Average price: R 70
Cuisine: Modern simplistic
Special features: Home-made bread for take away

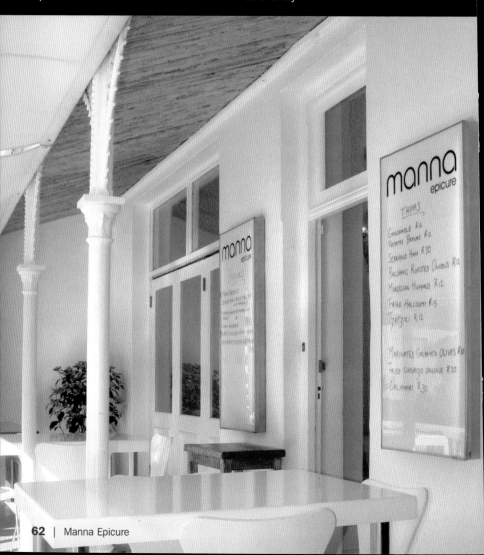

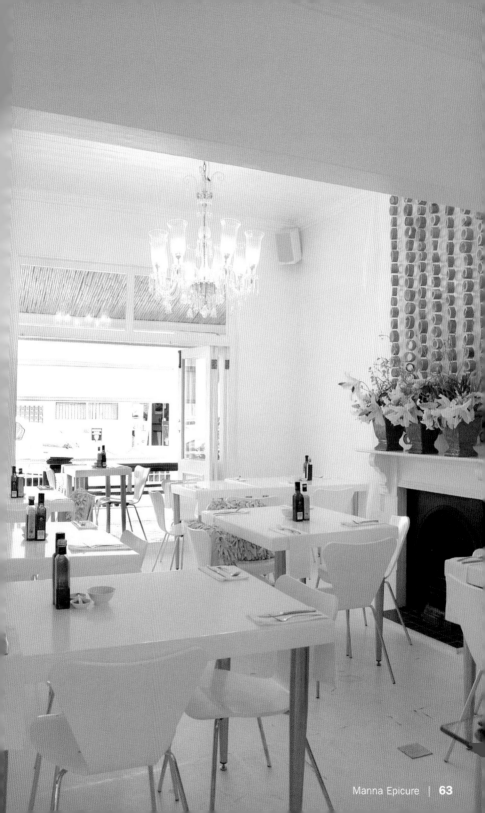

Duck Liver Parfait

Entenleberparfait
Parfait de foie gras de canard
Parfait de hígado de pato
Parfait di fegato d'anatra

1/2 onion, diced
120 ml Porto
30 ml Brandy
2 twigs thyme
1 bay leave
1/2 clove of garlic, chopped

4 eggs
14 oz butter, melted and lukewarm
14 oz foie gras (duck)
Salt

Capers, pesto and pickles for decoration

Combine onion, Porto, Brandy, thyme, bay leave and garlic in a small pot and reduce until syrupy Strain. Combine the foie gras with the syrup in a blender and mix. Gradually add the eggs and 7 oz melted butter, until it resembles a smooth mixture. Pour through a fine sieve and place in a ovenproof dish. Poach in a bain-marie in a 280 °F oven for 45-55 minutes. Remove from the oven and cool down at room temperature. Combine the pâté with 7 oz melted butter in a blender and mix. Line a ovenproof dish with plastic foil, pour the mixture into the dish and chill overnight in the refrigerator. To serve, cut the pâté in slices and garnish with capers, pesto and pickles.

1/2 Zwiebel, gewürfelt
120 ml Portwein
30 ml Brandy
2 Zweige Thymian
1 Lorbeerblatt
1/2 Knoblauchzehe, gehackt

4 Eier
400 g Butter, flüssig und lauwarm
400 g Entenleber
Salz

Kapernäpfel, Pesto und Essiggemüse als Dekoration

Die Zwiebel mit dem Portwein, Brandy, Thymian, Lorbeerblatt und Knoblauch in einen kleinen Topf geben und zu einem Sirup einkochen. Anschließend abseihen. Die Leber mit dem Sirup in eine Küchenmaschine geben und pürieren. Nach und nach die Eier und 200 g Butter zugeben, bis sich eine glatte Mischung ergibt. Durch ein feines Sieb gießen und in eine Auflaufform geben. Im Wasserbad bei 140 °C 45-55 Minuten pochieren. Aus dem Ofen nehmen und bei Zimmertemperatur abkühlen lassen. Die Terrine mit 200 g Butter in eine Küchenmaschine geben und mixen. Eine Auflaufform mit Klarsichtfolie auskleiden, die Mischung in die Form geben und über Nacht im Kühlschrank fest werden lassen. Zum Servieren das Parfait in Scheiben schneiden und mit Kapernäpfeln, Pesto und Essiggemüse garnieren.

/2 oignon en dés
20 ml de porto
0 ml de brandy
branches de thym
 feuille de laurier
/2 gousse d'ail haché

 œufs
00 g de beurre liquide tiède
00 g de foie gras de canard
el

ornichons de câprier, pesto et légumes au
inaigre pour la décoration

Mettre dans une petite casserole l'oignon, le porto, le brandy, le thym, le laurier et l'ail et cuire un sirop. Passer ensuite au chinois. Mettre le foie et le sirop dans un robot ménager et réduire en purée. Incorporer peu à peu les œufs et 200 g de beurre jusqu'à obtention d'un mélange lisse. Passer au tamis fin et verser dans un plat à gratin. Pocher au bain-marie à 140 °C entre 45-55 minutes. Retirer du four et laisser refroidir à température ambiante. Mettre cette terrine dans le robot avec 200 g de beurre et mixer. Chemiser un plat à gratin avec une feuille de plastique alimentaire, y verser l'appareil et faire prendre au réfrigérateur pendant une nuit. Pour servir, couper le parfait en tranches et garnir de cornichons de câprier, pesto et légumes au vinaigre.

/2 cebolla, en dados
20 ml de oporto
0 ml de brandy
 ramitas de tomillo
 hoja de laurel
/2 diente de ajo, picado

 huevos
00 g de mantequilla, líquida y tibia
00 g de hígado de pato cebado
al

lcaparrones, pesto y encurtidos para decorar

Ponga la cebolla con el oporto, el brandy, el tomillo, la hoja de laurel y el ajo en una cazuela pequeña y cueza hasta obtener un jarabe. Cuele después el jarabe. Introduzca el hígado y el jarabe en un robot de cocina y triture. Incorpore poco a poco los huevos y 200 g de mantequilla hasta conseguir una mezcla uniforme. Viértala en un molde a través de un colador fino. Cueza la mezcla en el horno al baño maría a 140 °C entre 45 y 55 minutos. Saque el molde del horno y deje que se enfríe a temperatura ambiente. Vierta el contenido del molde en un robot de cocina junto con 200 g de mantequilla y triture. Forre un molde con film transparente, vierta la mezcla en él y déjelo en el frigorífico durante la noche para que la mezcla se endurezca. Para servir el parfait córtelo en rodajas y decore con alcaparrones, pesto y encurtidos.

1/2 cipolla tagliata a dadini
120 ml di vino Porto
30 ml di brandy
2 ramoscelli di timo
1 foglia di alloro
1/2 spicchio d'aglio tritato

4 uova
400 g di burro tiepido fuso
400 g fegato grasso d'anatra

Sale

Per la guarnizione: capperi, pesto e sottacati

Mettere la cipolla con il Porto, il brandy, il timo, la foglia di alloro e l'aglio in un pentolino e lasciar addensare cuocendo. Quindi filtrare. Frullare il fegato e la salsa. Aggiungere un uovo alla volta e 200 g di burro, fino ad ottenere un composto omogeneo. Passare al setaccio fine e versare in uno stampo. Cuocere in forno a bagnomaria per 45-55 minuti a 140 °C. Estrarre dal forno e lasciar raffreddare a temperatura ambiente, quindi frullare con 200 g di burro. Rivestire uno stampo con pellicola trasparente, versarvi il composto e farlo rassodare in frigorifero per una notte. Servire il parfait a fette, guarnito con capperi, pesto e sottacati.

Manolo

Design: Kevin Engelbrecht, Leen Filius | Chef: Philip Alcock
Owners: Leen Filius, Peter Zeeuw

30 Kloof Street | Gardens, 8001 | Cape Town
Phone: +27 21 422 4747
www.manolo.co.za
Opening hours: Mon–Sun 7 pm until late
Average price: R 65
Cuisine: Classical French and English cuisine with a South African influence
Special features: Three dining rooms, bar and smoking room, outdoor deck and
glass enclosed veranda with a view on Table Mountain

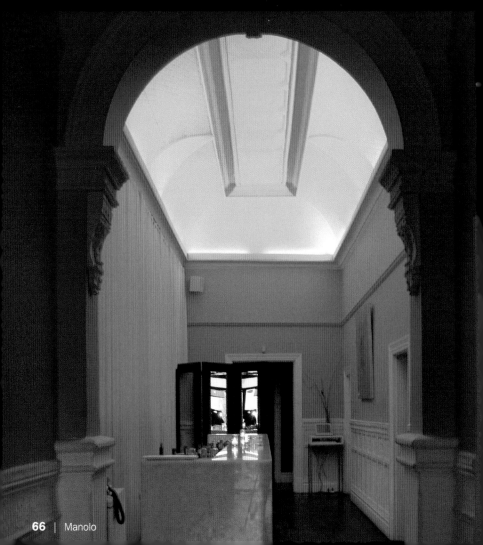

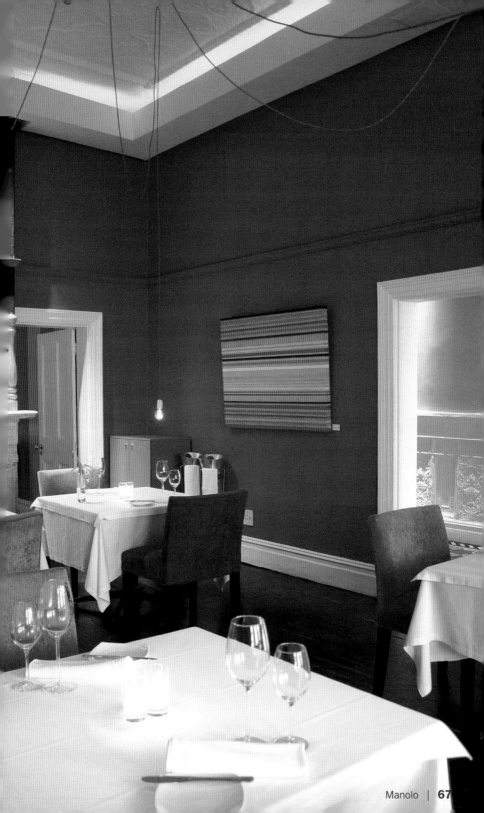

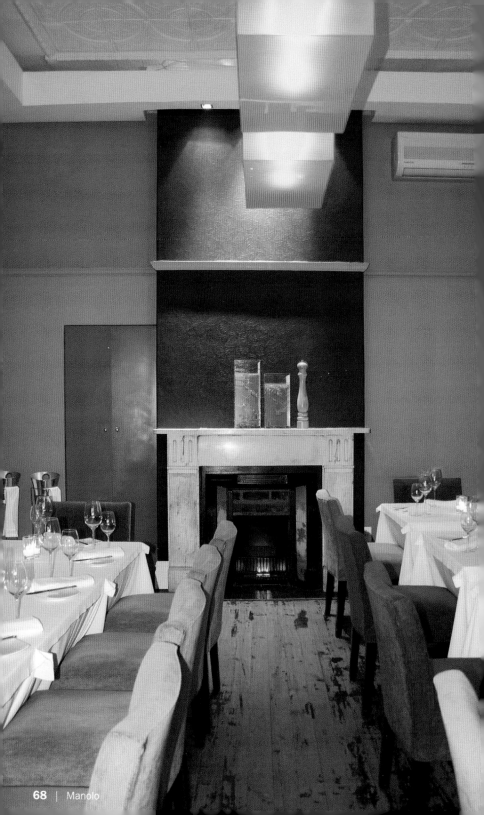

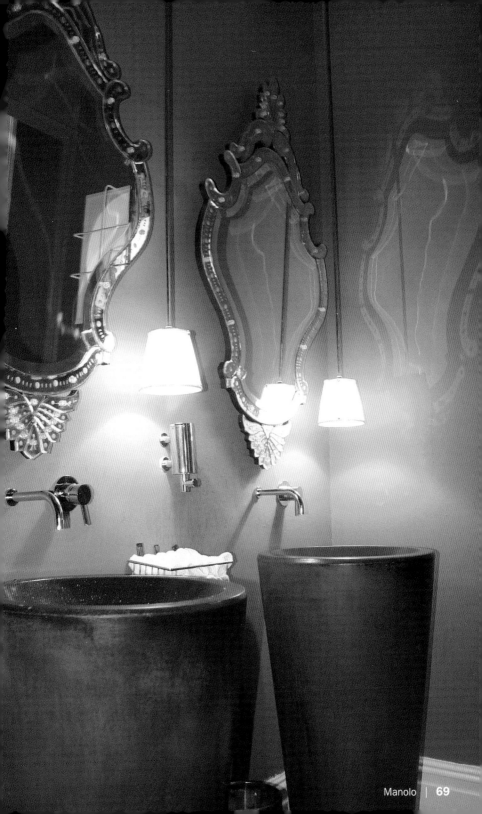

Sesame Tuna
with Cucumber Salad and Prawns

Sesam-Thunfisch mit Gurkensalat und Garnelen

Thon au sésame avec salade de concombre et crevettes

Atún con sésamo y ensalada de pepino y cigalas

Tonno al sesamo con insalata di cetrioli e gamberi

100 ml Mirin (sweet rice wine, or Sherry as a substitute)
1 tbsp sugar
1/2 red and green chili each, chopped
3 tbsp pine nuts, roasted and chopped
2 cucumbers, peeled and seeded
8 prawns, cleaned and cooked
4 pieces tuna, 6 ½ oz each
Salt, pepper
3 tbsp sesame oil
2 tsp Wasabi
4 tbsp sesame seeds, roasted
Leek julienne, deep-fried
Fresh cilantro

Heat up the Mirin and add sugar until dissolved Stir in the chilies and chill. Once mixture has cooled, add the pine nuts and set aside dressing.
Cut the cucumbers in fine julienne and combine with half of the dressing. Season the tuna with salt and pepper and sear both sides for 1 minute. Spread the Wasabi on the tuna and toss the fish in sesame seeds.
Divide the cucumber salad onto four plates and place two prawns on each salad, then garnish with fried leek julienne. Cut the tuna in half, place beside the salad and drizzle with the rest of the dressing. Garnish with fresh cilantro.

100 ml Mirin (süßer Reiswein, ersatzweise Sherry)
1 EL Zucker
Je 1/2 rote und grüne Chilischote, gehackt
3 EL Pinienkerne, geröstet und gehackt
2 Gurken, geschält und entkernt
8 Garnelen, geputzt und gekocht
4 Stück Thunfisch à 180 g
Salz, Pfeffer
3 EL Sesamöl
2 TL Wasabi
4 EL Sesam, geröstet
Lauchstreifen, frittiert
Frischer Koriander

Den Mirin erhitzen, den Zucker darin auflösen und die Chilischoten unterrühren. Abkühlen lassen, die Pinienkerne zugeben und das Dressing beiseite stellen.
Die Gurken in feine Julienne schneiden und mit der Hälfte des Dressings mischen. Den Thunfisch würzen, von beiden Seiten 1 Minute scharf anbraten, mit Wasabi bestreichen und im Sesam wälzen.
Den Gurkensalat auf vier Teller verteilen, jeweils zwei Garnelen darauf setzen und mit frittierten Lauchstreifen garnieren. Den Thunfisch halbieren, neben den Salat setzen und etwas Dressing darum geben. Mit frischem Koriander garnieren.

00 ml de mirin (saké sucré ; à défaut sherry)
1 c. à soupe de sucre
1/2 piment rouge et 1/2 piment vert hachés
3 c. à soupe de pignons grillés et hachés
2 concombres épluchés et épépinés
3 crevettes nettoyées et cuites
4 morceaux de thon de 180 g chacun
Sel, poivre
3 c. à soupe d'huile de sésame
2 c. à café de wasabi
4 c. à soupe de sésame grillé
Lamelles de poireau frites
Coriandre fraîche

Réchauffer le mirin, y diluer le sucre et ajouter les piments. Laisser refroidir, ajouter les pignons et réserver la sauce.
Couper les concombres en julienne fine et mélanger avec la moitié de la sauce. Assaisonner le thon, saisir une minute sur les deux faces, badigeonner de wasabi et enrober de sésame.
Répartir la salade de concombre sur quatre assiettes, déposer respectivement deux crevettes et garnir de lamelles de poireau frites. Couper le thon en deux, dresser à côté de la salade et arroser de sauce tout autour. Décorer de coriandre fraîche.

100 ml de mirin (vino dulce de arroz, puede sustituirse por jerez)
1 cucharada de azúcar
1/2 guindilla roja y 1/2 guindilla verde, picadas
3 cucharadas de piñones, tostados y picados
2 pepinos, pelados y despepitados
8 cigalas, limpias y cocidas
4 filetes de atún, de 180 g cada uno
Sal, pimienta
3 cucharadas de aceite de sésamo
2 cucharaditas de wasabi
4 cucharadas de semillas de sésamo, tostadas
Tiras de puerro, fritas
Cilantro fresco

Caliente el mirin, diluya en él el azúcar, añada las guindillas y remueva. Deje enfriar la mezcla, incorpore los piñones y reserve el aliño.
Corte los pepinos en juliana y mezcle las tiras con la mitad del aliño. Sazone el atún, fríalo bien por ambos lados, píntelo con wasabi y rebócelo en las semillas de sésamo.
Reparta la ensalada de pepino en cuatro platos, ponga dos cigalas en cada uno y decore con las tiras de cebollino frito. Corte los filetes de atún en mitades, colóquelas junto a la ensalada y vierta por encima el aliño. Decore con cilantro fresco.

100 ml di mirin (vino di riso dolce, in sostituzione sherry)
1 cucchiaio di zucchero
Mezzo peperoncino rosso e mezzo peperoncino verde tritati
3 cucchiai di pinoli tostati e tritati
2 cetrioli sbucciati e privati dei semi
8 gamberi puliti e bolliti
4 pezzi di tonno da 180 g ciascuno
Sale, pepe
3 cucchiai di olio di sesamo
2 cucchiai di wasabi
4 cucchiai di sesamo tostato
Fili di porro fritti
Coriandolo fresco

Riscaldare il mirin, scioglievi lo zucchero ed incorporarvi il peperoncino. Lasciar raffreddare, aggiungere i pinoli e tenere da parte il dressing.
Tagliare a listarelle i cetrioli ed unirli alla metà del dressing. Condire il tonno, rosolarlo a fuoco vivo da entrambi i lati per 1 minuto, spennellarlo con il wasabi e passarlo nel sesamo.
Ripartire in quattro piatti l'insalata di cetrioli, adagiare in ogni piatto due gamberi e guarnire con i fili di porro fritti. Tagliare a metà il tonno, porlo accanto all'insalata e versarvi un po' di dressing. Guarnire con coriandolo fresco.

Miam Miam

Design, Owner: Shaï Mazliah

196 ½ Long Street | City Centre, 8001 | Cape Town
Phone: +27 21 422 5823
miammiam@telkomsa.net
Opening hours: Mon–Fri 5 pm to 2 am, Sat 7:30 pm to 2 am
Average price: R 30 (cocktail)
Cuisine: Cosmopolitan, drinks
Special features: Vip room, magnificent lighting

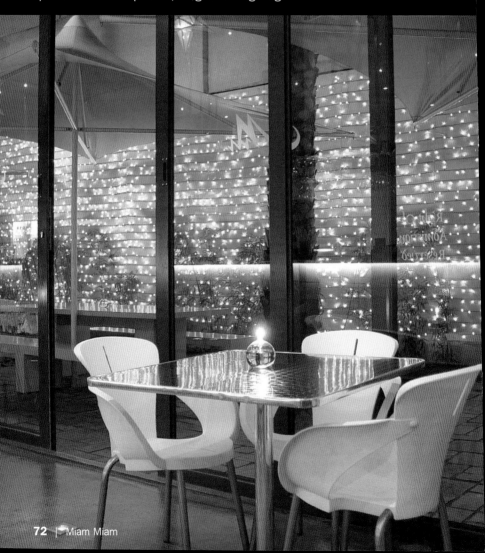

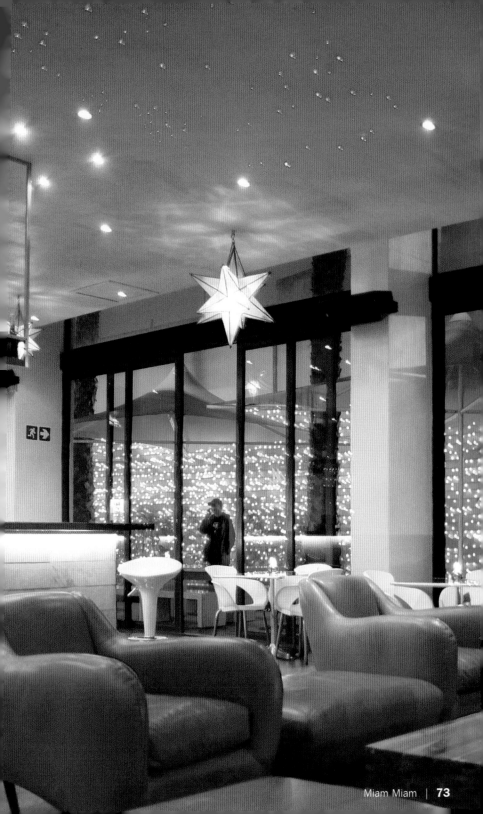

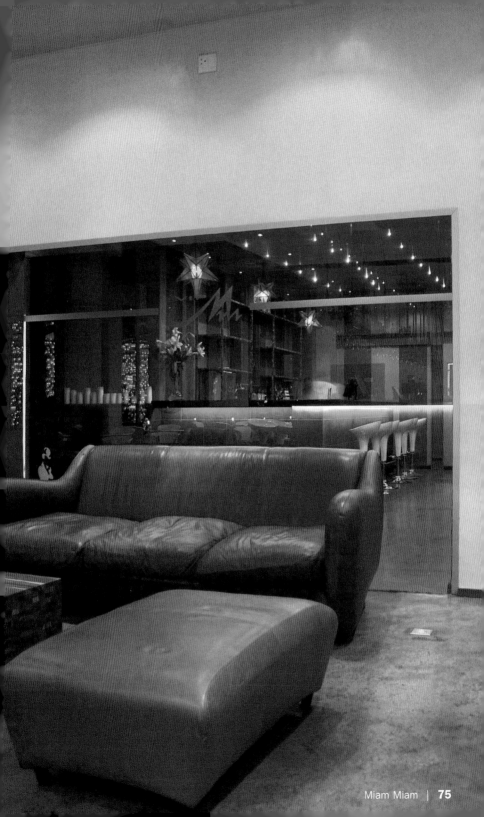

one.waterfront

Design: François du Plessis | Executive Chef: Bruce Robertson

Cape Grace, West Quay Road | V&A Waterfront, 8002 | Cape Town
Phone: +27 21 418 0520
www.onewaterfront.co.za
Opening hours: Mon–Sun breakfast 6:30 am to 11 am, lunch noon to 3 pm, dinner
7 pm to 10:30 pm
Average price: R 150
Cuisine: Creative and inspiring cuisine, with a strong South African influence

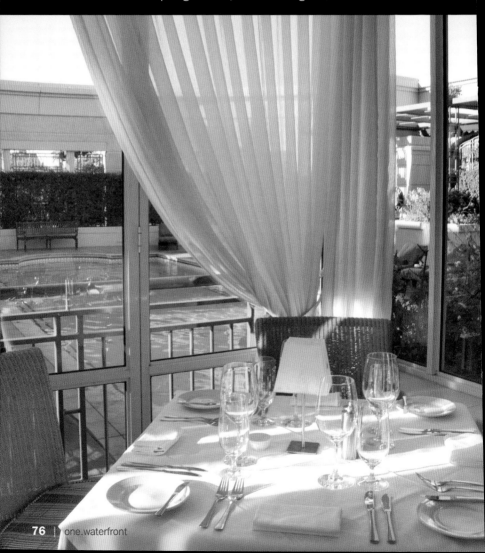

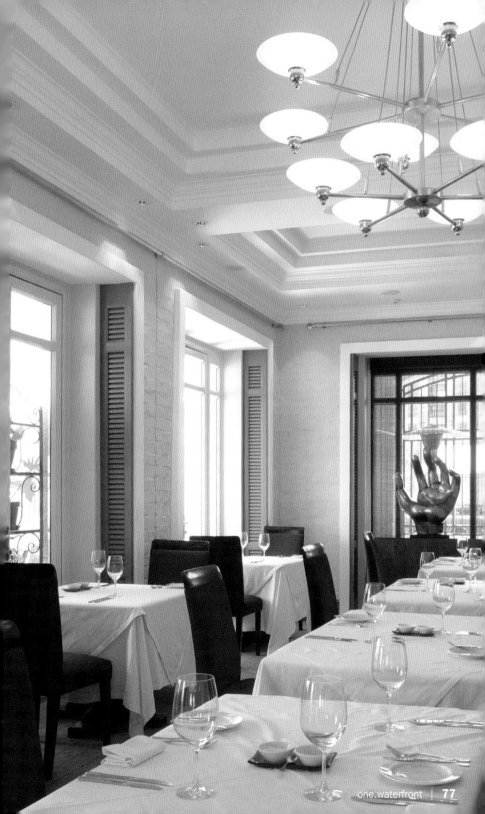

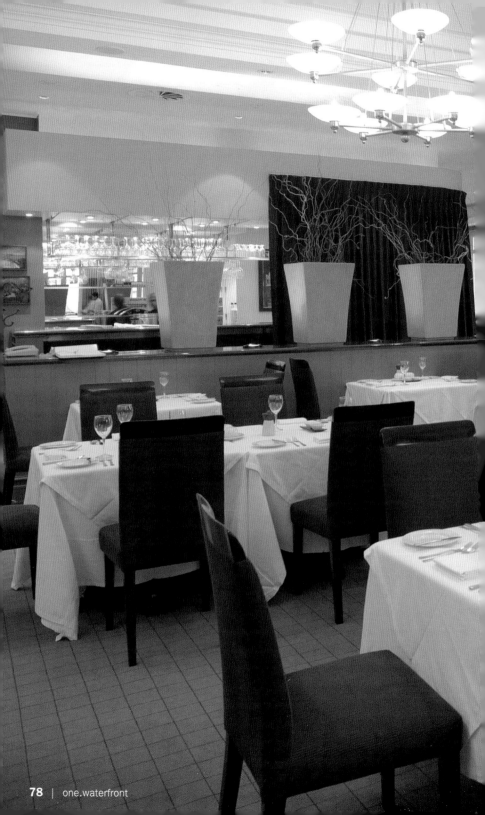

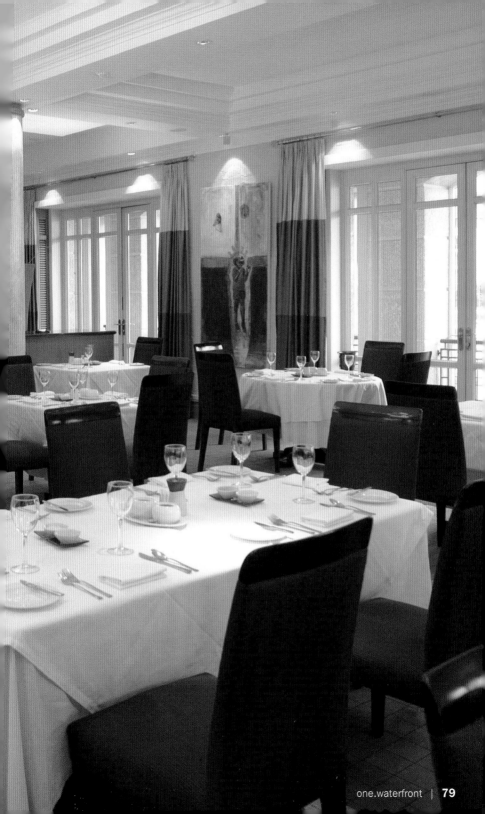

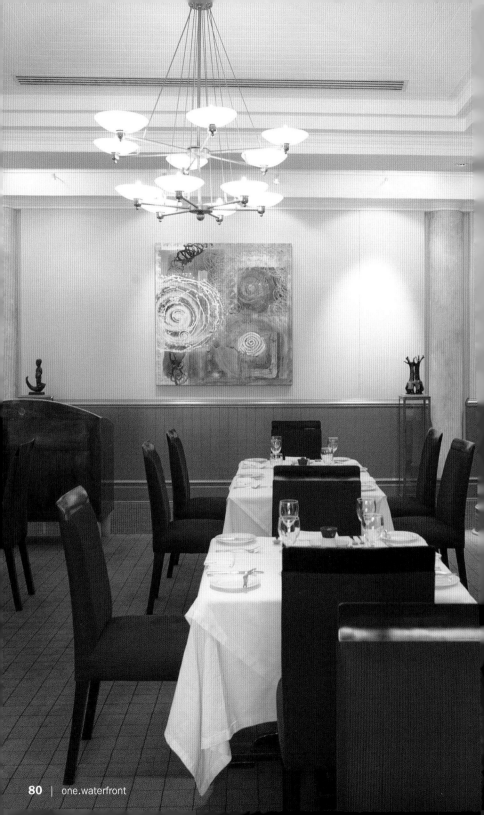

Wild Caesar Salad

Wilder Caesarsalat

Salade césar sauvage

Ensalada césar silvestre

Insalata selvatica di Cesare

2 oz mixed lettuce
1 oz flat leave parsley
1 oz curly parsley
1 oz frisée lettuce
1 oz wild rocket
12 croutons, 3/4 x 3/4 inch
4 slices warthog carpaccio
4 slices springbok carpaccio
4 slices ostrich carpaccio
24 chives, two chives tied together
24 Kapenta (small fishes)
4 tbsp Parmesan shavings
2 tbsp pistachios, chopped
4 Parmesan chips for decoration

Dressing:
1 egg yolk
1 tbsp vinegar
1 tsp mustard

180 ml sunflower oil
1 tsp lemon juice
1 tsp Parmesan, grated
1/2 clove of garlic, chopped
1 anchovy
Salt, pepper, sugar
Combine all ingredients in a blender and mix until smooth. Chill.

Wrap each crouton with one slice of carpaccio, place two Kapenta on top and tie together with chives. Mix the lettuce and toss with prepared dressing. Divide into four glasses and place one of each carpaccio cube in every glass. Divide the Parmesan shavings, pistachios and Parmesan chips evenly in each glass.

60 g gemischter Blattsalat
30 g glatte Petersilienblätter
30 g krause Petersilienblätter
30 g Friséesalat
30 g Rucolasalat
12 Croûtons, 2 x 2 cm
4 Scheiben Warzenschwein-Carpaccio
4 Scheiben Springbock-Carpaccio
4 Scheiben Straußen-Carpaccio
24 Halme Schnittlauch, immer 2 Halme zusam-mengebunden
24 Kapenta (kleine Fische)
4 EL Parmesanspäne
2 EL Pistazien, gehackt
4 Parmesanchips zur Dekoration

Dressing:
1 Eigelb

1 EL Essig
1 TL Senf
180 ml Sonnenblumenöl
1 TL Zitronensaft
1 TL Parmesan, gerieben
1/2 Knoblauchzehe, gehackt
1 Sardelle
Salz, Pfeffer, Zucker
Alle Zutaten in einen Mixer geben und so lange mixen, bis ein glattes Dressing entsteht. Kalt stellen.

Je einen Croûton mit einer Scheibe Carpaccio umwi-ckeln, zwei Kapenta auflegen und mit Schnittlauch festbinden. Den Salat mischen, das Dressing unter-heben und in vier Gläser verteilen. Von jedem Carpaccio-Würfel einen in jedes Glas geben und Parmesanspäne, Pistazien und Parmesanchips gleichmäßig in die Gläser verteilen.

60 g de laitue mélangée
30 g de feuilles de persil plat
30 g de feuilles de persil frisé
30 g de salade frisée
30 g de rucola
12 croûtons de 2 cm x 2 cm
4 tranches de carpaccio de phacochère
4 tranches de carpaccio de springbok
4 tranches de carpaccio d'autruche
24 brins de ciboulette, toujours attachés par deux
24 kapenta (petits poissons)
4 c. à soupe de copeaux de parmesan
2 c. à soupe de pistaches hachées
4 chips au parmesan pour la décoration

Sauce:
1 jaune d'œuf
1 c. à soupe de vinaigre

1 c. à café de moutarde
180 ml d'huile de tournesol
1 c. à café de jus de citron
1 c. à café de parmesan râpé
1/2 gousse d'ail haché
1 anchois
Sel, poivre, sucre
Mettre tous les ingrédients dans un mixeur et mixer jusqu'à obtention d'une sauce lisse. Placer au frais.

Enrouler un croûton dans chaque tranche de carpaccio, déposer deux kapenta et ficeler avec de la ciboulette. Mêler les salades, ajouter la sauce et répartir dans quatre verres. Déposer un cube de chaque carpaccio dans chaque verre et répartir également les copeaux de parmesan, les pistaches et les chips au parmesan.

60 g de hojas de lechugas de diferentes clases
30 g de hojas de perejil liso
30 g de hojas de perejil rizado
30 g de escarola
30 g de rucola
12 picatostes, 2 x 2 cm
4 lonchas de carpaccio de facóquero
4 lonchas de carpaccio de antílope saltador
4 lonchas de carpaccio de avestruz
24 hojas de cebollino, atadas de 2 en 2
24 kapentas (pequeños pescados)
4 cucharadas de queso parmesano rallado
2 cucharadas de pistachos, picados
4 láminas de parmesano para decorar

Aliño:
1 yema
1 cucharada de vinagre
1 cucharadita de mostaza

180 ml de aceite de girasol
1 cucharadita de zumo de limón
1 cucharadita de queso parmesano, rallado
1/2 diente de ajo, picado
1 anchoa
Sal, pimienta, azúcar
Pase todos los ingredientes por el pasapurés hasta obtener un aliño uniforme. Reserve en el frigorífico.

Envuelva cada picatoste con una loncha de carpaccio, ponga en dos de los lados una kapenta y átelo todo con dos cebollinos. Mezcle las hojas de lechuga con el aliño y reparta la ensalada en cuatro vasos. Ponga en cada uno de ellos un picatoste de carpaccio y el parmesano rallado, los pistachos y las láminas de parmesano a partes iguales.

60 g di lattuga mista
30 g di foglie di prezzemolo liscio
30 g di foglie di prezzemolo riccio
30 g di indivia riccia
30 g di rucola
12 crouton di 2 x 2 cm
4 fette di carpaccio di facocero
4 fette di carpaccio di springbok
4 fette di carpaccio di struzzo
24 fili di erba cipollina legati a 2
24 kapenta (piccoli pesci)
4 cucchiai di scaglie di parmigiano
2 cucchiai di pistacchi tritati
Per la guarnizione: 4 bocconcini di parmigiano

Dressing:
1 tuorlo d'uovo
1 cucchiaio di aceto

1 cucchiaino di senape
180 ml di olio di semi di girasole
1 cucchiaino di succo di limone
1 cucchiaino di parmigiano grattugiato
1/2 spicchio d'aglio tritato
1 acciuga
Sale, pepe, zucchero
Frullare tutti gli ingredienti fino ad ottenere una salsa omogeneo. Mettere in frigo.

Avvolgere ogni croutons in una fetta di carpaccio, adagiarvi due kapenta e legare con l'erba cipollina. Mischiare l'insalata, unirvi il dressing e ripartirla in quattro bicchieri. Mettere in dado di carpaccio in ogni bicchiere e ripartirvi in parti uguali le scaglie di parmigiano, i pistacchi ed i bocconcini di parmigiano.

Pigalle

Design: Deborah Witken | Chef: Lee Kox | Owner: Victor Goncalves

57 Somerset Road | Greenpoint, 8001 | Cape Town
Phone: +27 21 421 4343
pigalle@mweb.co.za
Opening hours: Mon–Sat noon to 3 pm, 7 pm till late
Average price: R 85
Cuisine: Portuguese, seafood
Special features: Fireplace, cigar lounge, live orchestra and dance floor with Titanic atmosphere

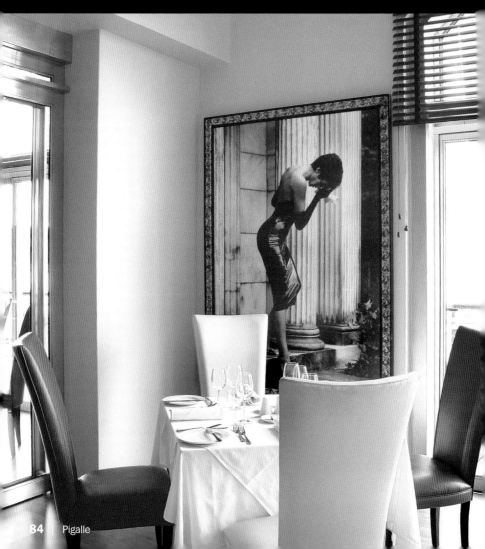

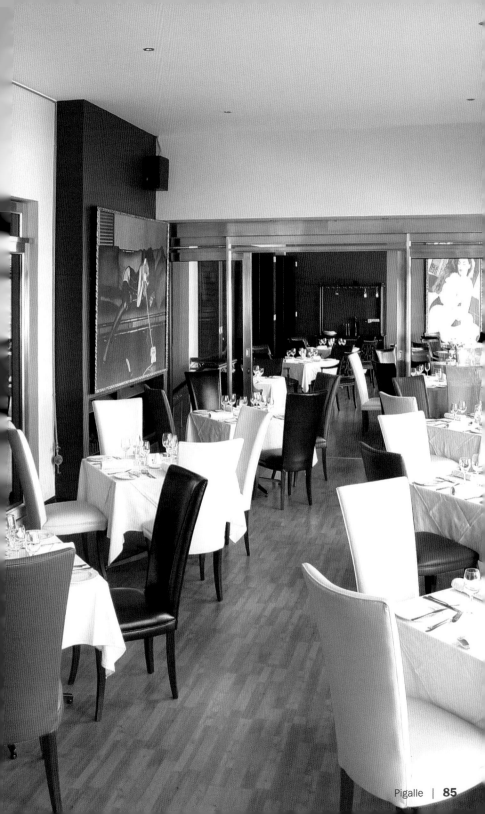

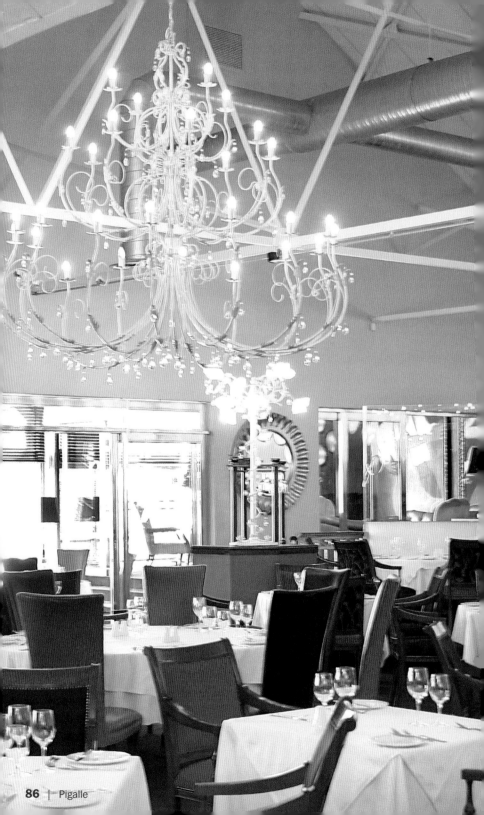

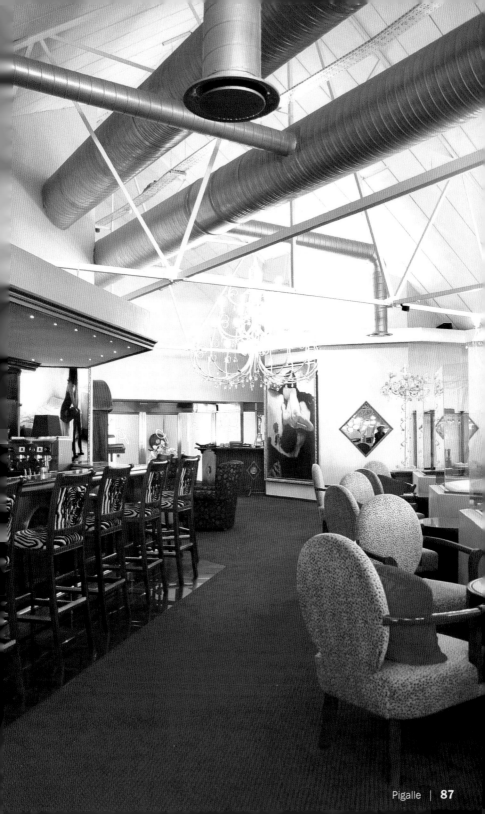

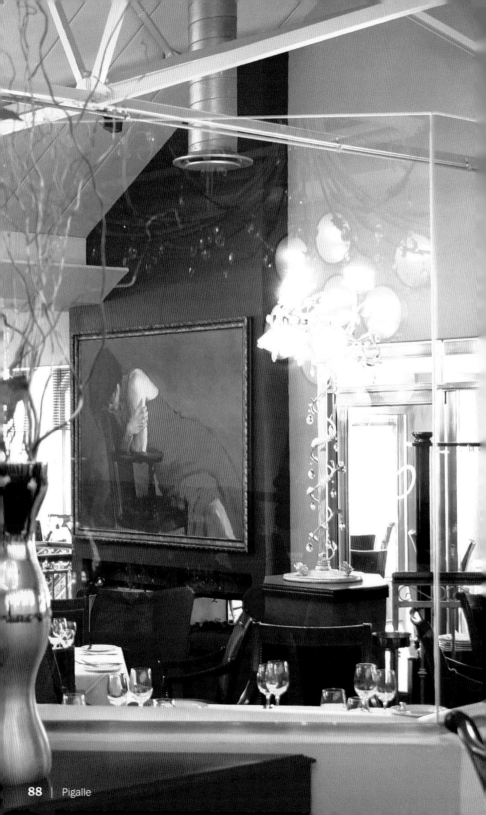

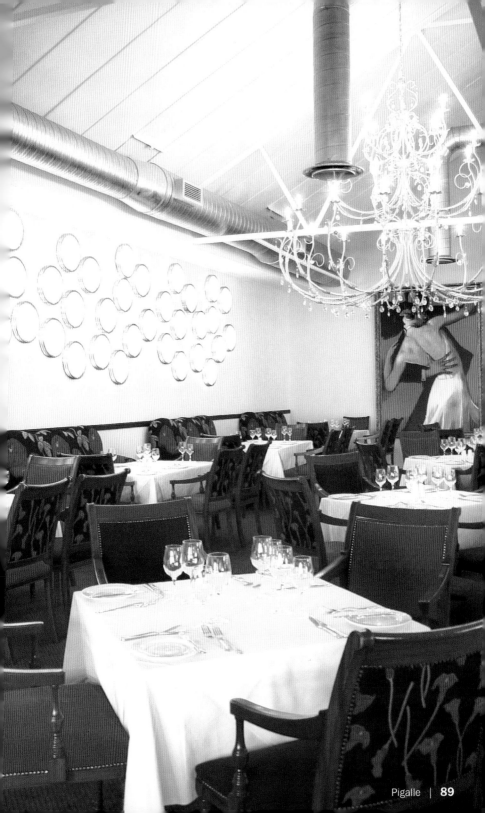

Planet Champagne & Cocktail Bar

Design: Graham Viney | Chef: Stephen Templeton

76 Orange Street | Gardens, 8000 | Cape Town
Phone: +27 21 483 1000
www.mountnelson.co.za/planet
Opening hours: Mon–Sun 5 pm until late, Fri 3 pm until late
Average price: Food R 30, cocktails R 30
Cuisine: Light meals including oysters and decadent desserts
Special features: Terrace overlooks the Mount Nelson Hotel gardens

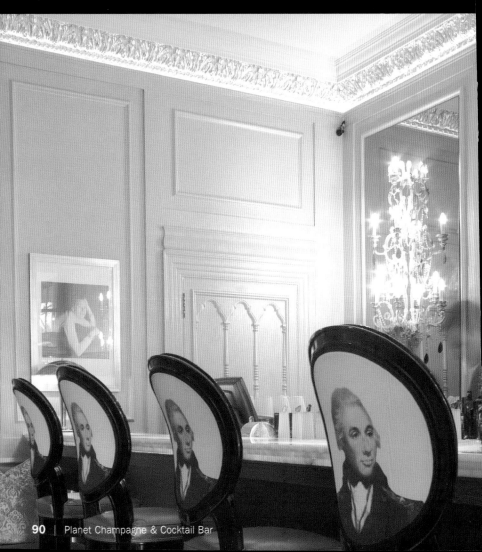

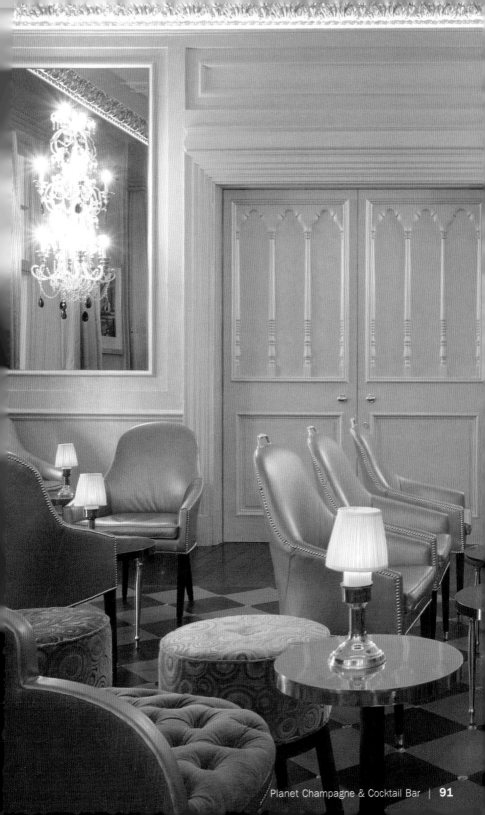

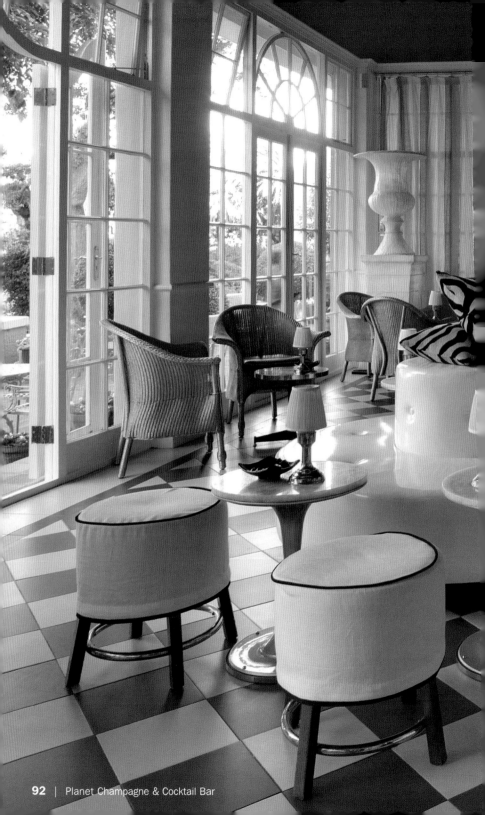

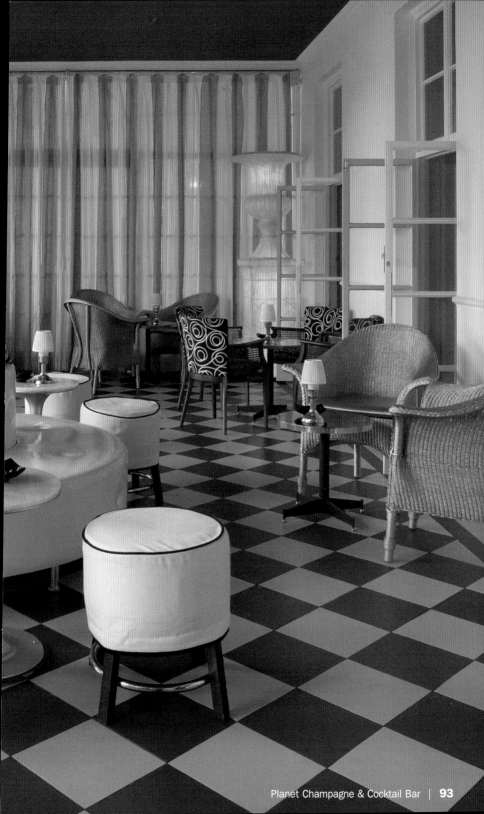

Relish

Design: Eitel Malan | Chef: Robert Bam | Owner: Richard Walsh

70 New Church Street | Tamboerskloof, 8001 | Cape Town
Phone: +27 21 422 3584
www.relish.co.za
Opening hours: Mon–Fri noon to late, Sat–Sun 5 pm to late
Average price: R 70
Cuisine: Continental fusion
Special features: Three floors with stunning views of Table Mountain

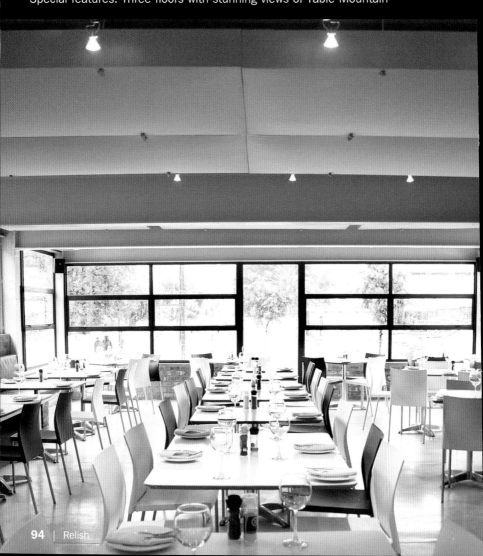

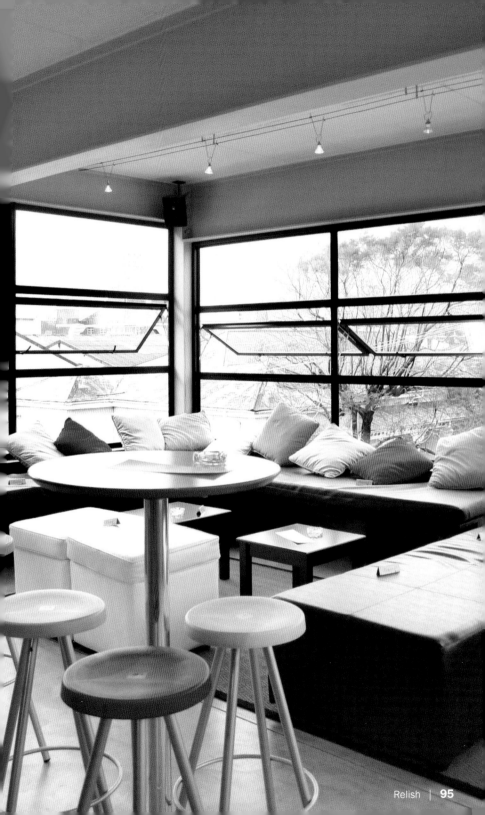

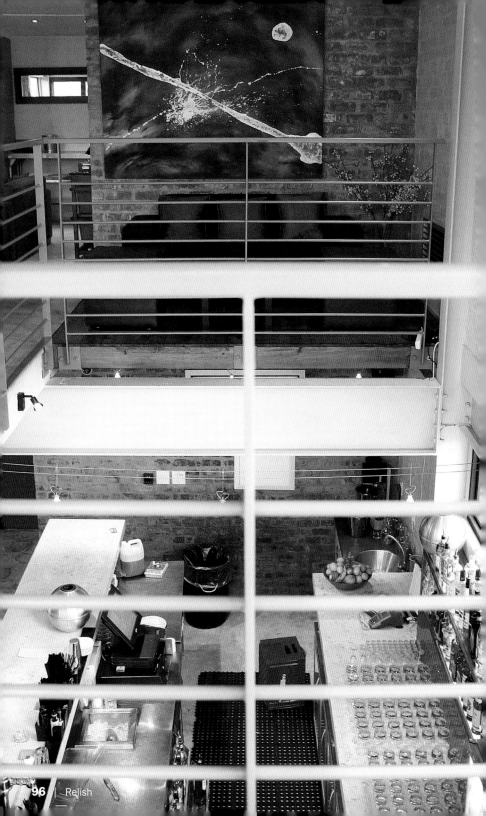

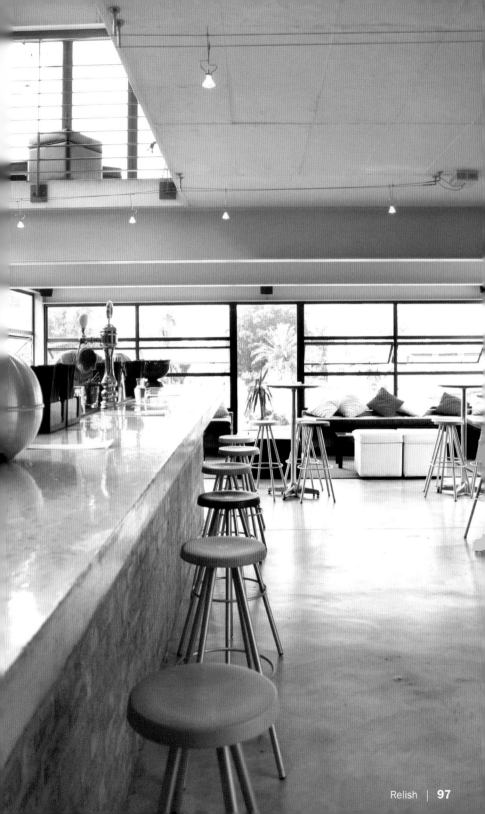

Rhodes House

Design, Owner: Giorgio Nava

60 Queen Victoria Street | Gardens, 8001 | Cape Town
Phone: +27 21 424 8844
www.rhodeshouse.com
Opening hours: 10 pm to 4 am (2 to 3 days a week)
Average price: Winter R 50 entrance fee, summer R 80, drinks R 25
Cuisine: Platters on request from 95 Keerom
Special features: Various lounges

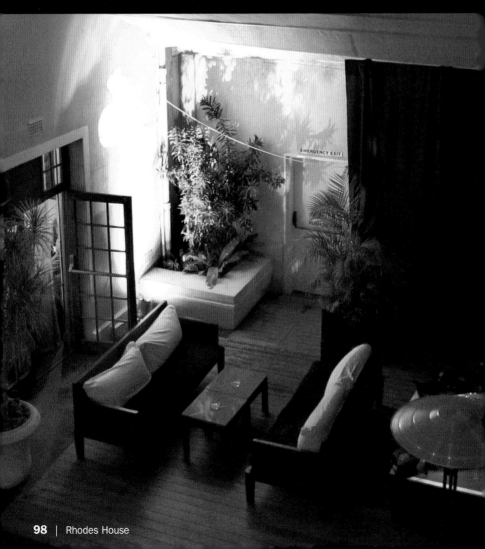

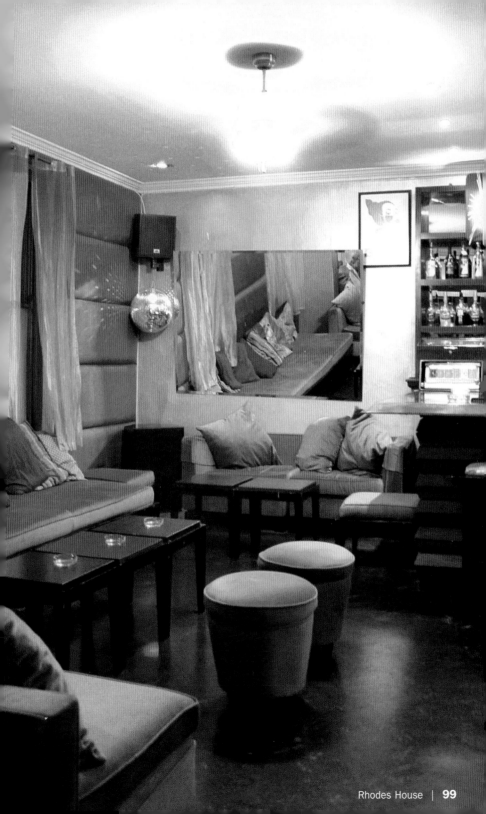

Saigon

Design: Anton De Kock | Chef: Nguyen Van My
Owner: Ernst Fischer

Corner of Kloof and Camp Streets | Gardens, 8001 | Cape Town
Phone: +27 21 424 7670
saigoncpt@iafrica.com
Opening hours: Sun–Fri noon to 2:30 pm, Sun–Sat 6 pm to 10:30 pm
Average price: R 50
Cuisine: Asian fusion, sushi
Special features: Smoking section on the 1st floor, bar, view on Table Mountain

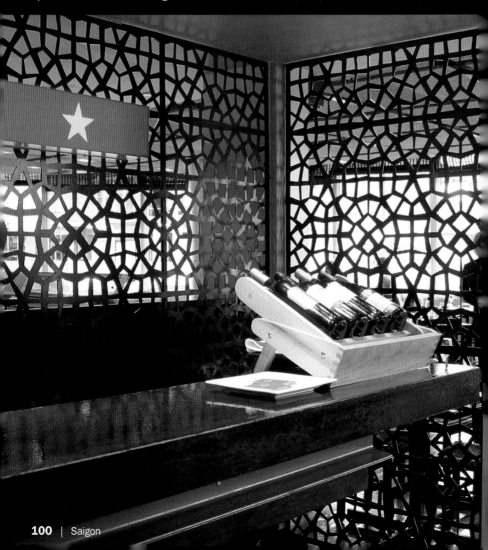

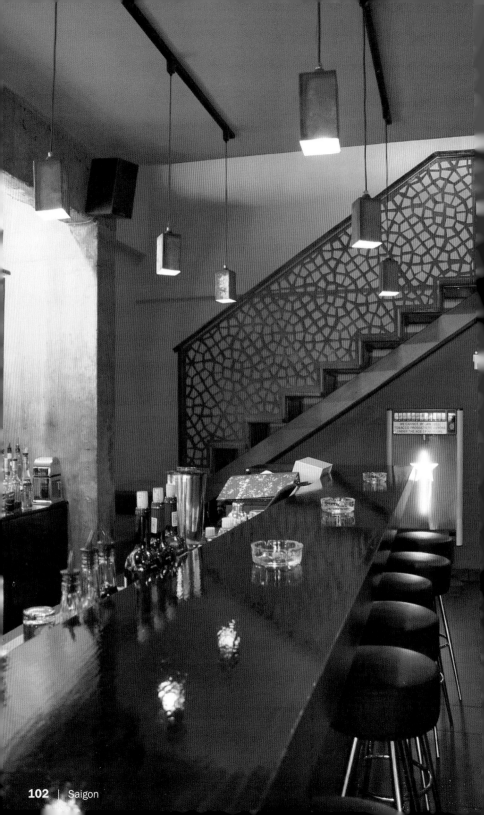

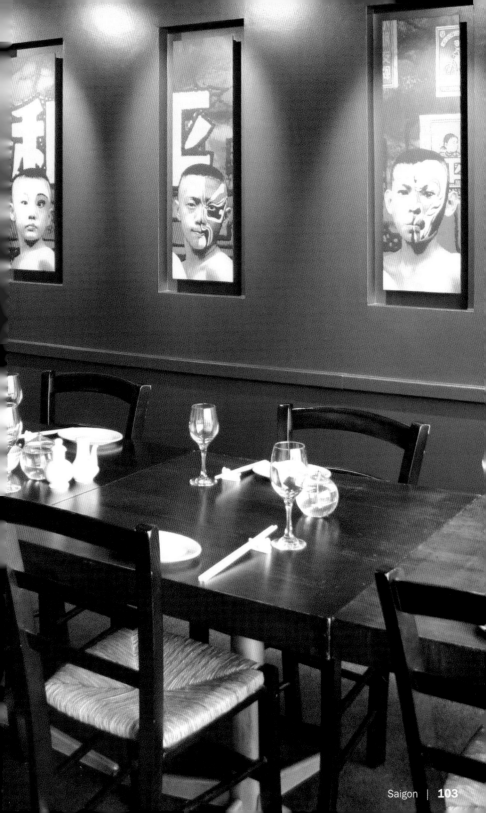

Prawn-Lettuce Roll

Garnelen-Salat-Rolle

Rouleau à la salade et aux crevettes

Rollitos de ensalada y de cigalas

Rotolo di insalata e di gamberi

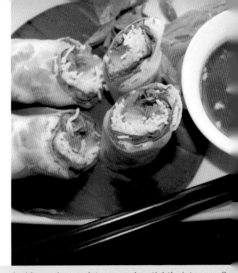

8 sheets rice paper
24 prawns, cooked
8 leaves of lettuce (e.g. ice lettuce)
1 carrot, in julienne
2 tsp sugar
30 ml rice vinegar
240 ml water
4 oz rice noodles, cooked
2 oz mint and basil leaves
1 cucumber, cut into thin slices
2 tbsp peanuts, chopped
Salt, pepper

Soak the rice paper. Season the carrot julienne with salt and set aside for 10 minutes. Combine sugar, vinegar and water into a bowl, and add fresh-squeezed carrot julienne into the marinade. Cover one rice paper with one leave of lettuce, mint and basil leaves, rice noodles, cucumber slices, marinated carrot and peanuts. Wrap the paper once into a roll. Then place three prawns inside and complete wrapping tightly into a roll. Chill. To serve, cut the rolls once diagonally and serve four halved rolls on each plate with peanut and chili sauce.

Peanut Sauce:
2 tbsp vegetable oil
1 clove of garlic, chopped
2 shallots, diced
1 tsp chili, chopped
4 oz rice
1 oz peanut butter
1 oz yellow bean paste
90 ml coconut water
Salt, pepper, sugar
2 tbsp chopped peanuts for decoration
Sauté the shallots and garlic in olive oil. Add the other ingredients and bring to a boil. Then mash and season. Pour into four small bowls and sprinkle with chopped peanuts.

8 Blätter Reispapier
24 Garnelen, gekocht
8 Salatblätter (z. B. Eisbergsalat)
1 Karotte, in Julienne geschnitten
2 TL Zucker
30 ml Reisessig
240 ml Wasser
120 g Reisnudeln, gekocht
60 g Minz- und Basilikumblätter
1 Gurke, in feine Scheiben geschnitten
2 EL Erdnüsse, gehackt
Salz, Pfeffer

Das Reispapier einweichen. Die Karottenjulienne salzen und 10 Minuten ziehen lassen. Zucker, Essig und Wasser mischen, die Karottenjulienne ausdrücken und in die Marinade geben. Jeweils ein Reispapier mit einem Salatblatt, Minz- und Basilikumblättern, Reisnudeln, Gurkenscheiben, marinierter Karotte und Erdnüssen belegen, einmal rollen, jeweils drei Garnelen auf die Rolle legen und fest zusammenrollen. Kalt stellen. Zum Servieren die Rollen einmal diagonal durchschneiden und je vier halbe Rollen pro Teller mit Erdnuss- und Chilisauce servieren.

Erdnuss-Sauce:
2 EL Pflanzenöl
1 Knoblauchzehe, gehackt
2 Schalotten, gehackt
1 TL Chili, gehackt
120 g Reis
30 g Erdnussbutter
30 g gelbe Bohnensauce
90 ml Kokosnusswasser
Salz, Pfeffer, Zucker
2 EL gehackte Erdnüsse zur Dekoration
Das Öl in einem kleinen Topf erhitzen, den Knoblauch und die Schalotten anschwitzen und die restlichen Zutaten zugeben. Einmal aufkochen, pürieren und abschmecken. In vier kleine Schalen füllen und mit gehackten Erdnüssen bestreuen.

8 feuilles de papier de riz
24 crevettes cuites
8 feuilles de salade (par ex. laitue d'hiver)
1 carotte en julienne
2 c. à café de sucre
30 ml de vinaigre de riz
240 ml d'eau
120 g de nouilles de riz cuites
60 g de feuilles de menthe et de basilic
1 concombre coupé en fines tranches
2 c. à soupe de cacahuètes hachées
Sel, poivre

Faire tremper le papier de riz. Saler la julienne de carotte et laisser macérer 10 minutes. Mélanger le sucre, le vinaigre et l'eau, presser la julienne de carotte et mettre dans la marinade. Sur chaque feuille de papier de riz, déposer une feuille de salade, des feuilles de menthe et de basilic, des nouilles de riz, des tranches de concombre, de la carotte marinée et des cacahuètes, rouler une fois,

déposer trois crevettes et enrouler fermement. Placer au frais. Pour servir, couper les rouleaux en diagonale et disposer quatre demi rouleaux par assiette avec de la sauce aux cacahuètes et au piment.

Sauce aux cacahuètes :
2 c. à soupe d'huile végétale
1 gousse d'ail haché
2 échalotes hachées
1 c. à café de piment haché
120 g de riz
30 g de beurre de cacahuètes
30 g de sauce de haricot jaune
90 ml d'eau de coco
Sel, poivre, sucre
2 c. à soupe de cacahuètes hachées pour décorer
Chauffer l'huile dans une casserole, y faire fondre l'ail et l'échalote et ajouter les ingrédients restants. Amener à ébullition, réduire en purée et assaisonner. Répartir dans quatre petites jattes et parsemer de cacahuètes hachées.

8 hojas de papel de arroz
24 cigalas, cocidas
8 hojas de lechuga (p.ej. iceberg)
1 zanahoria, en juliana
2 cucharaditas de azúcar
30 ml de vinagre de arroz
240 ml de agua
120 g de fideos de arroz, cocidos
60 g de hojas de menta y albahaca
1 pepino, en finas rodajas
2 cucharadas de cacahuetes, picados
Sal, pimienta

Ponga las hojas de papel de arroz en remojo. Sazone con sal las tiras de zanahoria y déjelas reposar durante 10 minutos. Mezcle el azúcar con el vinagre y el agua, escurra las tiras de zanahoria e introdúzcalas en el líquido. Ponga en cada hoja de arroz una hoja de lechuga, hojas de menta y de albahaca, fideos de arroz, rodajas de pepino, zanahoria marinada y cacahuetes. Enrolle las hojas una vez, ponga encina de

cada rollo tres cigalas. Enrolle las hojas complamente y reserve los rollitos en frío. Para servir los rollitos córtelos diagonalmente y ponga en cada plato cuatro mitades. Sirva con salsa de cacahuete y de guindilla.

Salsa de cacahuete:
2 cucharadas de aceite vegetal
1 diente de ajo, picado
2 chalotes, picados
1 cucharadita de guindilla, picada
120 g de arroz
30 g de mantequilla de cacahuete
30 g salsa amarilla de judías
90 ml de agua de coco
Sal, pimienta, azúcar
2 cucharadas de cacahuetes picados para decorar
Caliente el aceite en un cazo pequeño, rehogue en él el ajo y los chalotes y añada los demás ingredientes. Deje que hiervan una vez, hágalos puré después y sazone. Reparta la salsa en cuatro cuencos pequeños y esparza por encima los cacahuetes picados.

8 fogli di carta di riso
24 gamberi bolliti
8 foglie di insalata (ad esempio lattuga iceberg)
1 carota tagliata a listarelle
2 cucchiai di zucchero
30 ml di aceto di riso
240 ml d'acqua
120 g di pasta di riso cotta
60 g di foglie di menta e basilico
1 cetriolo tagliato a fette sottili
2 cucchiai di arachidi tritate
Sale, pepe

Ammorbidire la carta di riso. Salare le listarelle di carote e cuocerle per 10 minuti. Mischiare lo zucchero, l'aceto e l'acqua, strizzare le listarelle di carote ed immergerle nella marinata. Ricoprire ciascun foglio di carta di riso con una foglia di insalata, le foglie di menta e basilico, la pasta di riso, le fette di cetriolo, la carota marinata e le arachidi. Avvolgere una prima volta, disporre tre gamberi sul rotolo ed avvolgere bene il tutto. Mettere in frigo. Al momento di

servire, tagliare diagonalmente i rotoli e disporre in ogni piatto quattro mezzi rotoli condendoli con salsa di arachidi e peperoncino.

Salsa di arachidi:
2 cucchiai di olio vegetale
1 spicchio d'aglio tritato
2 scalogni tritati
1 cucchiaino di peperoncino tritato
120 g di riso
30 g di burro di arachidi
30 g di salsa di fagioli gialli
90 ml di acqua di noce di cocco
Sale, pepe, zucchero
Per la guarnizione: 2 cucchiai di arachidi tritate
Riscaldare l'olio in un pentolino, soffriggere l'aglio e gli scalogni ed unire gli altri ingredienti. Portare a cottura, passare col passaverdure, assaggiare e condire. Versare in quattro scodelline e cospargere con arachidi tritate.

Savoy Cabbage

Design: Leon Saven | Chef: Peter Pankhurst | Owner: Caroline Bagley

101 Hout Street | City Centre, 8001 | Cape Town
Phone: +27 21 424 2626
savoycab@iafrica.com
Opening hours: Mon–Fri noon to 2:30 pm, Mon–Sat 7 pm to 10:30 pm
Average price: R 100
Cuisine: Eclectic menu which varies daily
Special features: Champagne bar overlooking the restaurant

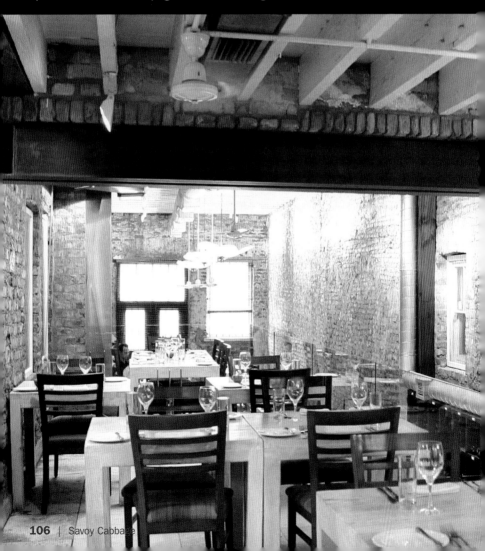

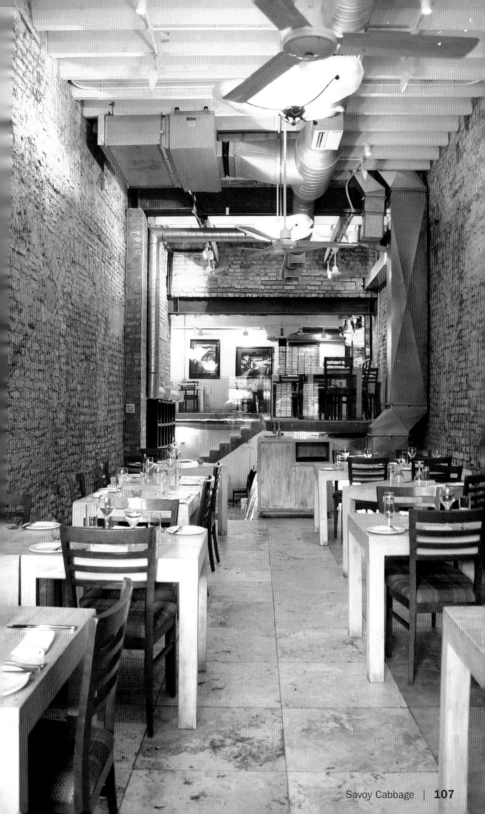

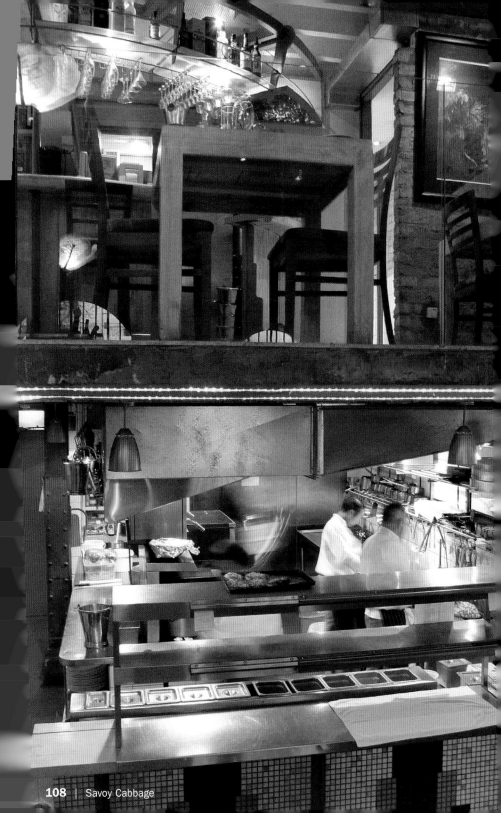

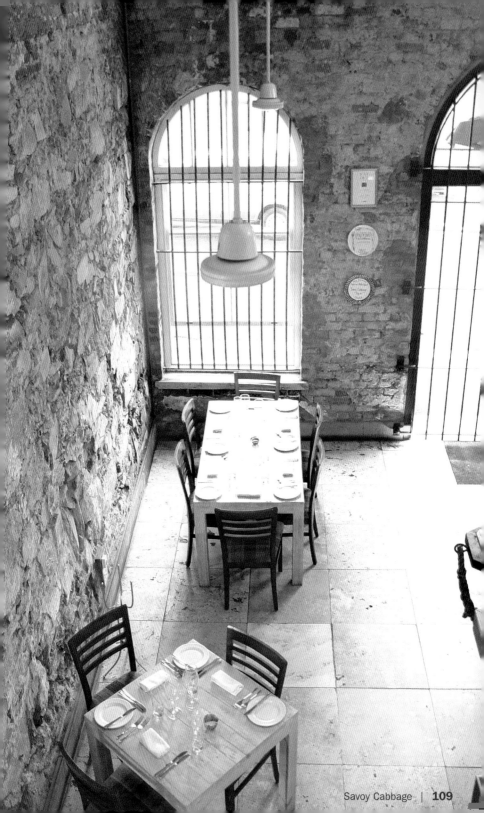

Grilled Warthog
Loin with Fig Sauce

Gegrilltes Warzenschweinfilet an
Feigensauce

Filet de phacochère grillé à la sauce aux
figues

Filete de facóquero a la parrilla sobre salsa
de higos

Filetto di facocero alla griglia con salsa di
fichi

1 warthog loin, cleaned
3 liters water
8 1/2 oz salt
4 oz sugar
6 juniper berries, crushed
1 tbsp peppercorns
2 twigs thyme
2 bay leaves
Bring all ingredients except the warthog loin to a
boil. Chill mixture and marinade loin overnight.

4 shallots, diced
1 clove of garlic, chopped
2 tbsp vegetable oil
7 oz sour figs, diced
1 twig thyme
300 ml white wine
800 ml veal fond

300 ml cream
Salt, pepper, sugar

Sauté shallots and garlic in vegetable oil. Add the
figs and thyme and sauté for 5 minutes. Reduce
with white wine and fill pan with veal fond. Reduce
to one half, refine with cream and season. Pour
through a strainer and keep warm.
Remove the loin from the marinade, tab dry and
season with salt and pepper. Sear meat in 3 tbsp
vegetable oil. Simmer in a 360 °F oven for 15
minutes. Cut the loin in slices and serve with fig
sauce. Serve potato-spinach ragout and cranber-
ries as side dish.

1 Warzenschweinfilet, ausgelöst
3 Liter Wasser
240 g Salz
120 g Zucker
6 Wacholderbeeren, zerdrückt
1 EL Pfefferkörner
2 Zweige Thymian
2 Lorbeerblätter
Alle Zutaten, außer dem Filet, aufkochen, abküh-
len lassen und das Fleisch über Nacht in der
Marinade einlegen.

4 Schalotten, gewürfelt
1 Knoblauchzehe, gehackt
2 EL Pflanzenöl
200 g saure Feigen, gewürfelt
1 Zweig Thymian
300 ml Weißwein

800 ml Kalbsfond
300 ml Sahne
Salz, Pfeffer, Zucker

Schalotten und Knoblauch in dem Pflanzenöl
anschwitzen, die Feigen und den Thymian zuge-
ben, 5 Minuten anschwitzen, mit Weißwein ablö-
schen und mit Kalbsfond auffüllen. Zur Hälfte
einkochen lassen, mit Sahne verfeinern und
abschmecken. Durch ein Sieb gießen und warm
stellen.
Das Filet aus der Marinade nehmen, trocken-
tupfen und mit Salz und Pfeffer würzen. In 3 EL
Pflanzenöl scharf anbraten und bei 180 °C 15
Minuten im Backofen garen. Das Filet in Scheiben
schneiden und mit Feigensauce servieren. Als
Beilage empfiehlt sich Kartoffel-Spinatgemüse
mit Preiselbeeren.

1 filet de phacochère dénervé
3 litres d'eau
240 g de sel
120 g de sucre
6 grains de genévrier écrasés
1 c. à soupe de grains de poivre
2 branches de thym
2 feuilles de laurier
Amener tous les ingrédients, sauf le filet, à ébullition, laisser refroidir et mettre la viande une nuit dans la marinade.

4 échalotes en dés
1 gousse d'ail haché
2 c. à soupe d'huile végétale
200 g de figues aigres en dés
1 branche de thym
300 ml de vin blanc

800 ml de fond de veau
300 ml de crème
Sel, poivre, sucre

Faire fondre les échalotes et l'ail dans l'huile, ajouter les figues et le thym, compoter 5 minutes, déglacer au vin blanc et mouiller avec le fond de veau. Faire réduire de moitié, ajouter la crème et assaisonner. Passer au chinois et conserver au chaud.
Retirer le filet de la marinade, sécher avec un essuie-tout, saler et poivrer. Saisir la viande à feu vif dans 3 c. à soupe d'huile végétale et cuire au four à 180 °C pendant 15 minutes. Couper le filet en tranches et servir avec la sauce aux figues. Conseil d'accompagnement : épinards et pommes de terre avec des airelles.

1 filete de facóquero sin hueso
3 litros de agua
240 g de sal
120 g de azúcar
6 enebrinas, machacadas
1 cucharada de granos de pimienta
2 ramitas de tomillo
2 hojas de laurel
Cueza todos los ingredientes excepto el filete, déjelos enfriar e introduzca después en la marinada a la carne. Déjelo reposar dentro durante la noche.

4 chalotes, en dados
1 diente de ajo, picado
2 cucharadas de aceite vegetal
200 g de higos agrios, en dados
1 ramita de tomillo
300 ml de vino blanco

800 ml de fondo de cordero
300 ml de nata
Sal, pimienta, azúcar

Rehogue los chalotes y el ajo en el aceite vegetal, añada los higos y el tomillo, rehogue los ingredientes 5 minutos, corte la cocción con el vino blanco y vierta dentro el fondo de cordero. Deje que la salsa cueza hasta que se reduzca a la mitad, refínela después con nata y sazone. Pásela por el colador y resérvela caliente.
Saque el filete de la marinada, séquela con una papel de cocina y salpiméntelo. Fríalo bien en 3 cucharadas de aceite vegetal y áselo después en el horno durante 15 minutos a 180 °C. Corte el filete en lonchas y sírvalas con la salsa de higos. Como acompañamiento le recomendamos patatas con espinacas y arándanos rojos.

1 filetto di facocero disossato
3 litri d'acqua
240 g di sale
120 g di zucchero
6 bacche di ginepro schiacciate
1 cucchiaio di grani di pepe
2 ramoscelli di timo
2 foglie di alloro
Portare a cottura tutti gli ingredienti tranne il filetto, lasciarli raffreddare e lascairvi marinare la carne per una notte.

4 scalogni tagliati a dadini
1 spicchio d'aglio tritato
2 cucchiai di olio vegetale
200 g di fichi in agrodolce tagliati a dadini
1 ramoscello di timo
300 ml di vino bianco

800 ml di sugo di vitello
300 ml di panna
Sale, pepe, zucchero

Dorare gli scalogni e l'aglio nell'olio vegetale, unirvi i fichi ed il timo, rosolare per 5 minuti, bagnare con il vino bianco ed allungare con il sugo di vitello. Lasciar asciugare finché la salsa non si sia ridotta della metà, aggiungere la panna, assaggiare e regolare il condimento. Passare al setaccio e tenere in caldo.
Togliere il filetto dalla marinata, asciugarlo, salarlo e peparlo. Rosolarlo a fuoco vivo in 3 cucchiai di olio vegetale e cuocerlo in forno per 15 minuti a 180 °C. Tagliare a fette il filetto e servirlo con la salsa di fichi. Come contorno consigliamo patate con spinaci e mirtilli rossi.

Tank

Design: Kate Moffatt | Owner: George Martin

Shop B15, Cape Quarter, 72 Waterkant Street | De Waterkant, 8001 | Cape Town
Phone: +27 21 419 0007
www.the-tank.co.za
Opening hours: Bar and lounge Mon–Sun noon till late, restaurant Mon–Sun noon to 3 pm, 6 pm to 11 pm
Average price: R 150
Cuisine: Pacific rim, sushi
Special features: Reminiscent of trendy Californian swank

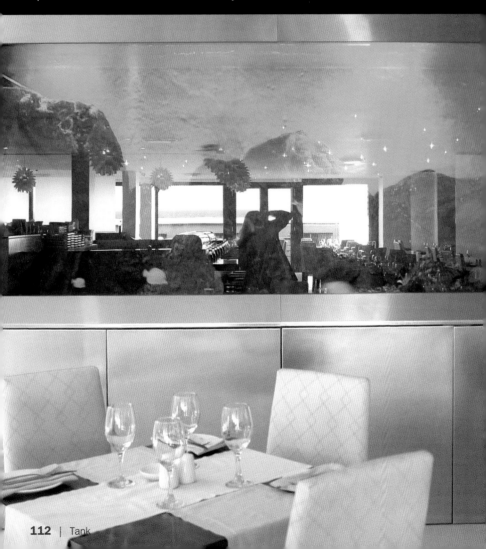

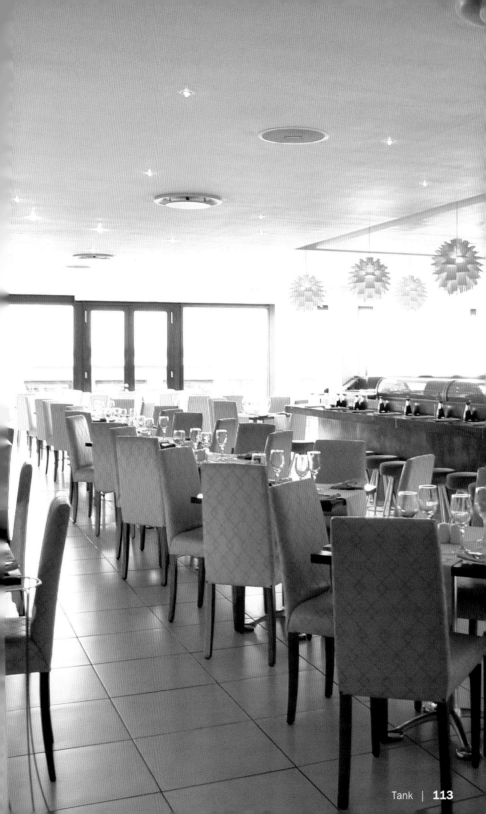

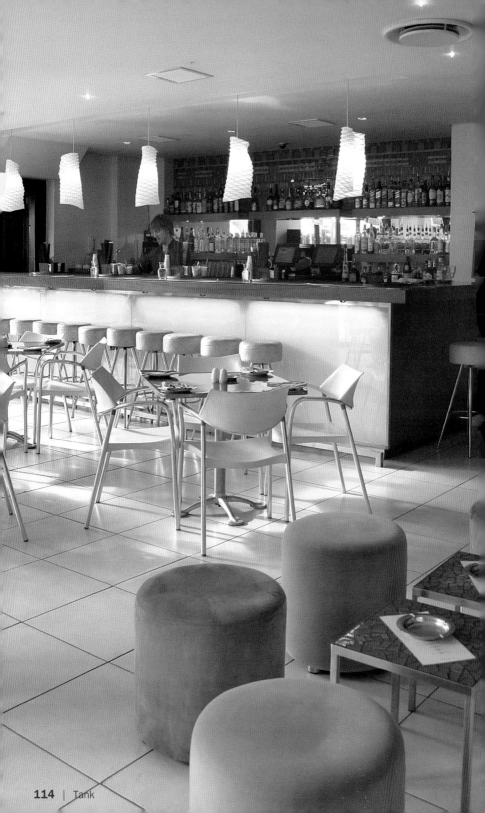

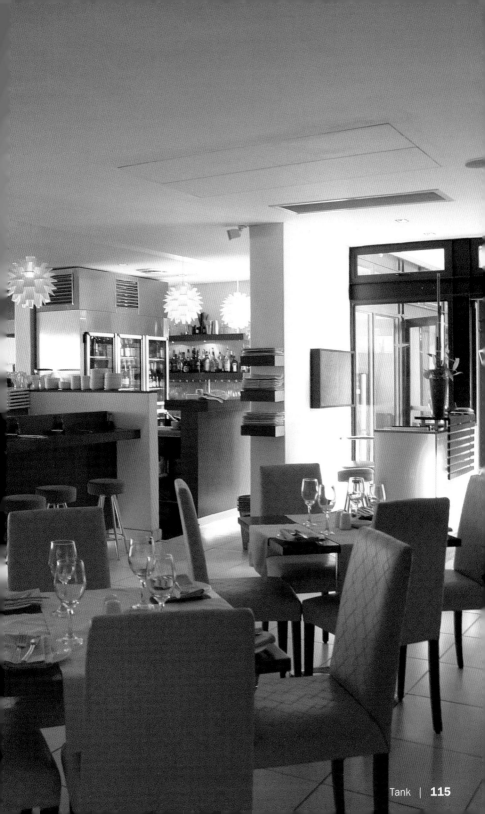

Tank Roll

Tank Rolle

Rolleau Tank

Rollo Tank

Rotolo Tank

4 sheets Nori
10 1/2 oz sushi rice, cooked
1 tbsp sugar
3 tbsp rice vinegar
Salt
2 oz salmon
2 oz tuna
2 oz yellow tail snapper
2 oz shrimp meat
1 oz caviar
1 avocado, cut in slices
1 cucumber
Wasabi and Gari (pickled ginger) for dipping

Mix sushi rice, sugar, rice vinegar and salt an
season for taste. Peel the cucumber and cut o
thin sheets around the cucumber in the size of
Nori sheet with a sharp knife.
Spread the rice on the sheets of Nori, place th
same amount of fish, shrimp meat, caviar an
avocado slices on each sheet of Nori and shap
into a tight roll. Chill. Just before serving, wrap th
rolls in the cucumber sheets and cut each roll int
six pieces. Serve with Wasabi and Gari.

4 Blätter Nori
300 g Sushi-Reis, gekocht
1 EL Zucker
3 EL Reisessig
Salz
60 g Lachs
60 g Thunfisch
60 g Gelbflossen-Snapper
60 g Krabbenfleisch
30 g Kaviar
1 Avocado, in Scheiben geschnitten
1 Gurke
Wasabi und Gari (eingelegter Ingwer) zum
Dippen

Den Sushi-Reis mit Zucker, Reisessig und Salz
mischen und abschmecken. Die Gurke schä-
len und mit einem scharfen Messer rundum
dünne Scheiben in der Größe eines Nori-Blatts
abschneiden.
Den Reis auf den vier Nori-Blättern vertei-
len, auf jedes Blatt die gleiche Menge Fisch,
Krabbenfleisch, Kaviar und Avocadoscheiben
geben und zu einer festen Rolle formen. Kalt
stellen. Kurz vor dem Servieren die Rollen in
die Gurkenscheiben wickeln und jede Rolle in
sechs Stücke schneiden. Mit Wasabi und Gari
servieren.

4 feuilles de nori
300 g de riz à sushi cuit
1 c. à soupe de sucre
3 c. à soupe de vinaigre de riz
Sel
60 g de saumon
60 g de thon
60 g de vivaneau à queue jaune
60 g de chair de crabe
30 g de caviar
1 avocat coupé en tranches
1 concombre
Wasabi et gari (gingembre mariné) pour tremper

Mélanger le riz à sushi avec le sucre, le vinaigre de riz et le sel et vérifier l'assaisonnement. Eplucher le concombre et couper tout autour avec un couteau aiguisé de fines tranches de la taille d'une feuille de nori.

Répartir le riz sur les quatre feuilles; déposer sur chacune d'elle la même quantité de poisson, de chair de crabe, de caviar et de tranches d'avocat et former un rouleau bien serré. Mettre au frais. Juste avant de servir, envelopper les rouleaux dans les tranches de concombre et couper chaque rouleau en six morceaux. Servir avec du wasabi et du gari.

4 hojas de nori
300 g de arroz sushi, cocido
1 cucharada de azúcar
3 cucharas de vinagre de arroz
Sal
60 g de salmón
60 g de atún
60 g de pargo dorado
60 g de carne de cangrejo
30 g de caviar
1 aguacate, en rodajas
1 pepino
Wasabi y Gari (jengibre macerado) para mojar

Mezcle el arroz sushi con el azúcar, el vinagre de arroz y la sal y condimente. Pele el pepino y con un cuchillo afilado córtelo en rodajas finas del tamaño de una hoja de nori. Reparta el arroz sobre las hojas de nori y ponga encima la misma cantidad de pescado, carne de cangrejo, caviar y rodajas de aguacate y enróllelas. Ponga los rollos en el frigorífico. Poco antes de servir envuelva los rollos con las rodajas de pepino y corte cada rollo en seis trozos. Sirva con wasabi y gari.

4 fogli di alghe nori
300 g di riso da sushi bollito
1 cucchiaio di zucchero
3 cucchiai di aceto di vino
Sale
60 g di salmone
60 g di tonno
60 g di snapper a pinne gialle
60 g di polpa di granchio
30 g di caviale
1 avocado tagliato a fette
1 cetriolo
Wasabi e gari (zenzero sottaceto) per intingere

Mischiare il riso con lo zucchero, l'aceto di riso e il sale, assaggiare e regolare il condimento. Sbucciare il cetriolo e, con un coltello affilato, tagliare tutt'intorno delle fette sottili delle dimensioni di un foglio di alghe nori. Ripartire il riso sui quattro fogli di alghe, distribuire su ogni foglio la stessa quantità di pesce, polpa di granchio, caviale e fette di avocado e formare un rotolo compatto. Mettere in frigo. Subito prima di servire, avvolgere i rotoli nelle fette di cetriolo e tagliare ciascun rotolo in sei pezzi. Servire con wasabi e gari.

The Gallery Cafe

Chef: Roberto Mazzola | Owners: Abilio & Franco Frazzitta

Urban Chic Boutique Hotel, 172 Long Street | City Centre, 8001 | Cape Town
Phone: +27 21 426 6119
www.urbanchic.co.za
Opening hours: Breakfast 7:30 am to 10:30 am, lunch noon to 3 pm,
dinner 6:30 pm to 10:30 pm
Average price: R 120
Cuisine: Italian

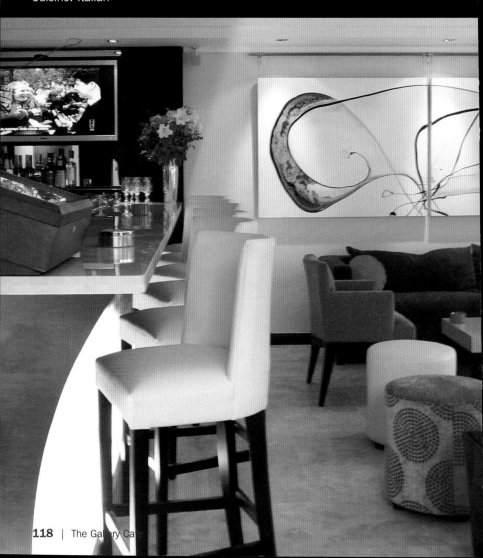

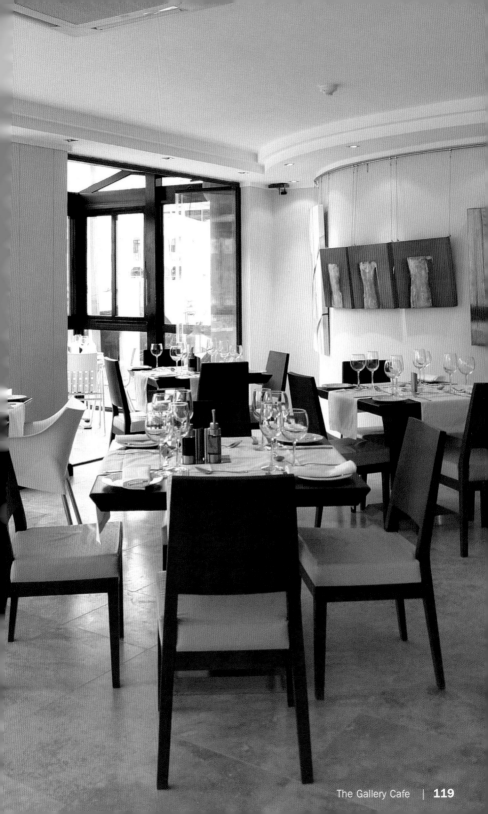

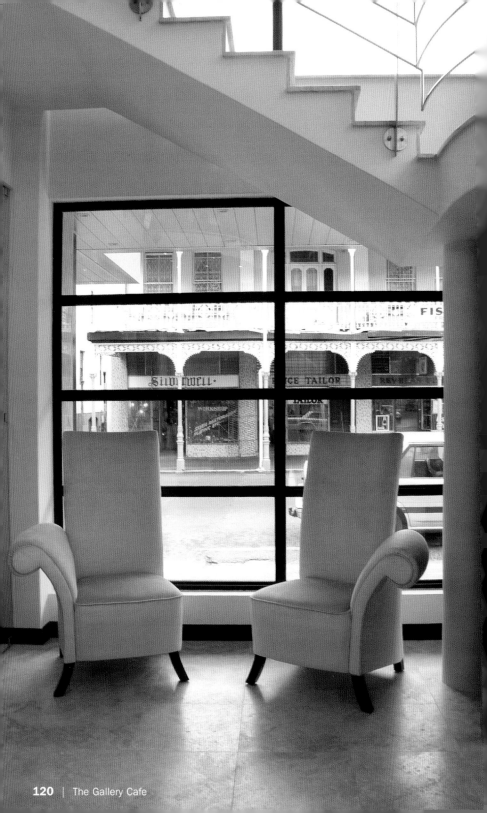

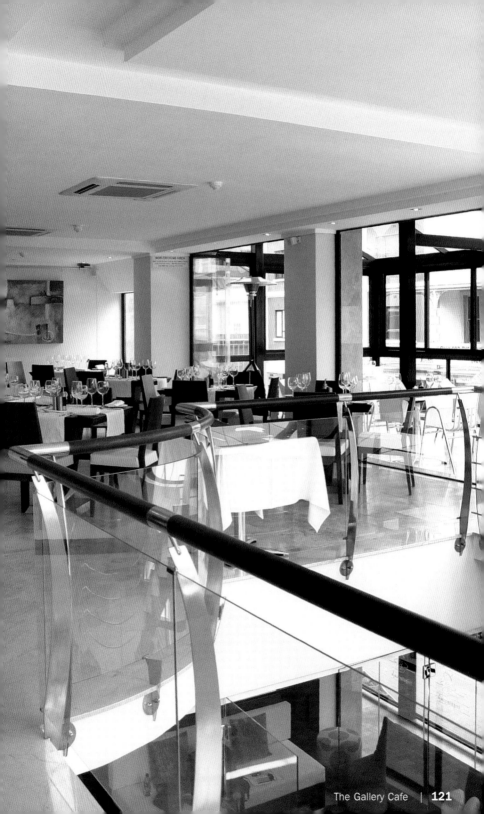

The Towers Club

Design: Gapp Architects, Yvonne Smuts | Chef: Marcus Taylor

Arabella Sheraton Grand Hotel, Lower Long Street | City Centre, 8001 | Cape Town
Phone: +27 21 412 8082
www.towersclub.co.za
Opening hours: Mon–Sun noon to 3 pm, 7 pm to 10:30 pm
Average price: Lunch R 120, dinner R 180
Cuisine: Modern European
Special features: Panoramic views to Table Mountain and ocean, complimentary valet parking

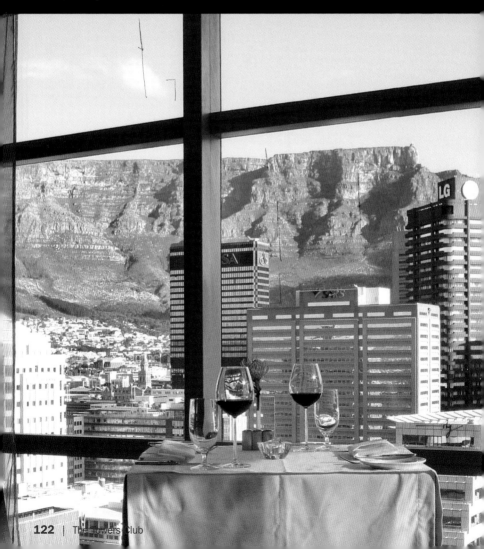

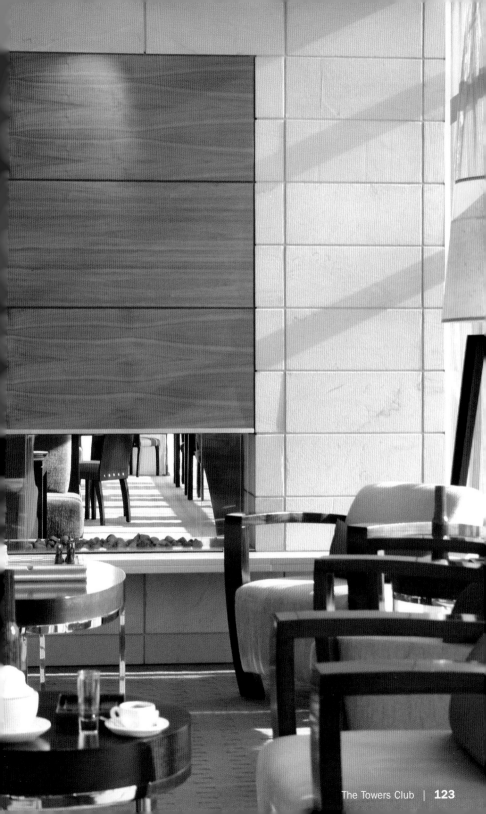

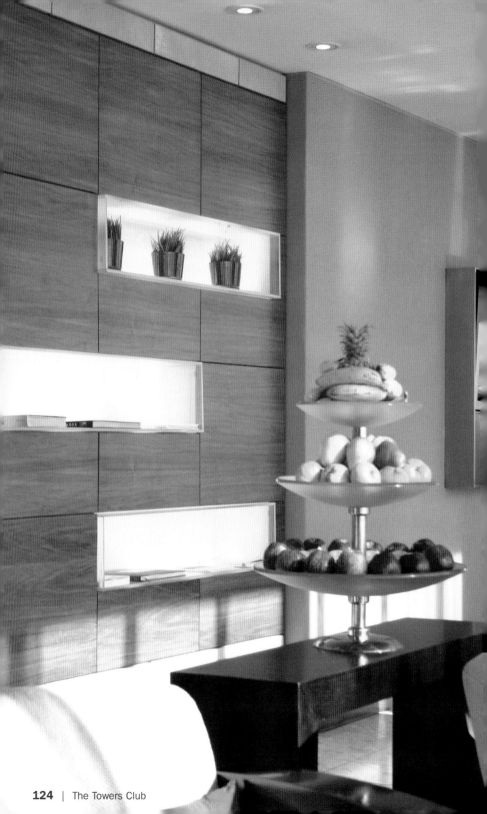

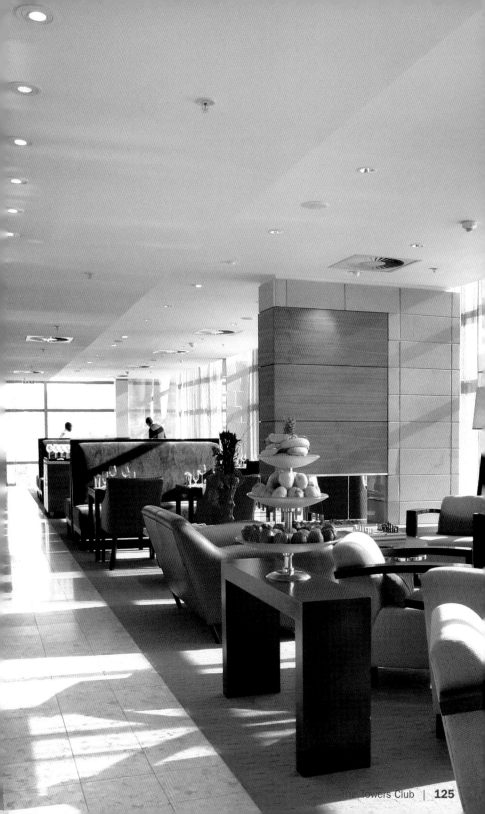

Soup Variations

Suppenvariationen

Variation de potages

Variaciones de sopas

Variazione di zuppe

1 tbsp butter
1 tbsp onion cubes
1 tsp flour
200 ml chicken stock
120 ml cream
3 1/2 oz fresh corn
1 pinch curcuma
Sauté the onion cubes in butter, add the flour and fill up with chicken stock. Bring to a boil to thicken the soup, then add cream and simmer. Add the corn, curcuma, salt and pepper, and mix until smooth.

2 tbsp olive oil
1/2 onion, diced
2 red bell peppers, cleaned and diced
300 ml chicken stock
1 pinch paprika
1 bay leaf
120 ml cream

Sauté onion cubes and bell pepper cubes in olive oil, fill pan with chicken stock. Add in the paprika and bay leaf, and simmer gently for 10 minutes. Season to taste and mash. Pour mixture through a strainer. Fill up with cream and season.

1 tbsp olive oil
1 tbsp onion cubes
1 tsp flour
400 ml milk
5 oz basil leaves and stems
2 oz spinach, fresh
Salt, pepper
Sauté onion cubes in olive oil, add flour and fill up with milk. Simmer for 10 minutes. Add in the basil leaves and spinach. Mash and season. Serve with shrimps tartlets.

1 EL Butter
1 EL Zwiebelwürfel
1 TL Mehl
200 ml Geflügelbrühe
120 ml Sahne
100 g frischer Mais
1 Prise Kurkuma
Die Zwiebelwürfel in Butter anschwitzen, das Mehl zugeben und mit der Geflügelbrühe ablöschen. Aufkochen lassen bis die Brühe etwas andickt, dann die Sahne zugeben und leise weiterköcheln. Den Mais hinzugeben, mit Kurkuma, Salz und Pfeffer würzen und glatt mixen.

2 EL Olivenöl
1/2 Zwiebel, gewürfelt
2 rote Paprika, geputzt und gewürfelt
300 ml Geflügelbrühe
1 Prise Paprika

1 Lorbeerblatt
120 ml Sahne
Zwiebelwürfel und Paprikawürfel in Olivenöl anschwitzen, mit Geflügelbrühe aufgießen, Paprika und Lorbeerblatt zugeben und 10 Minuten leise köcheln lassen. Würzen, pürieren und durch ein Sieb gießen. Mit Sahne auffüllen und abschmecken.

1 EL Olivenöl
1 EL Zwiebelwürfel
1 TL Mehl
400 ml Milch
150 g Basilikumblätter und -stiele
60 g Spinat, roh
Salz, Pfeffer
Zwiebelwürfel in Olivenöl anschwitzen, Mehl zugeben und mit Milch auffüllen. 10 Minuten köcheln, Basilikum und Spinat zugeben, pürieren und würzen. Mit Shrimpstarteletts servieren.

1 c. à soupe de beurre
1 c. à soupe de dés d'oignon
1 c. à café de farine
200 ml de bouillon de volaille
120 ml de crème
100 g de maïs frais
1 pincée de curcuma
Faire fondre les dés d'oignon dans le beurre, ajouter la farine et mouiller avec le bouillon de volaille. Bouillir jusqu'à ce que le bouillon épaississe un peu, ajouter alors la crème et laisser mijoter à feu doux. Ajouter le maïs, le curcuma, du sel et du poivre. Mixer longuement.

2 c. à soupe d'huile d'olive
1/2 oignon en dés
2 poivrons rouges nettoyés en dés
300 ml de bouillon de volaille
1 pincée de paprika
1 feuille de laurier
120 ml de crème

Faire fondre les dés d'oignon et de poivron dans l'huile d'olive, mouiller avec le bouillon de volaille, ajouter le paprika et la feuille de laurier ; laisser mijoter 10 minutes à feu doux. Assaisonner, réduire en purée et passer au chinois. Incorporer la crème et rectifier l'assaisonnement.

1 c. à soupe d'huile d'olive
1 c. à soupe de dés d'oignon
1 c. à café de farine
400 ml de lait
150 g de feuilles et de tiges de basilic
60 g d'épinards crus
Sel, poivre
Faire fondre les dés d'oignon dans l'huile d'olive, ajouter la farine et mouiller avec le lait. Laisser mijoter 10 minutes, ajouter le basilic et les épinards, réduire en purée et assaisonner. Servir avec des tartelettes aux crevettes.

1 cucharada de mantequilla
1 cucharada de dados de cebolla
1 cucharadita de harina
200 ml de caldo de volatería
120 ml de nata
100 g de maíz fresco
1 pizca de cúrcuma
Rehogue los dados de cebolla en la mantequilla, añada la harina y corte la cocción con el caldo de volatería. Deje que hierva hasta que el caldo se espese un poco, incorpore después la nata y deje que siga hirviendo a fuego lento. Añada el maíz, condimente con la cúrcuma, la sal y la pimienta y bata hasta conseguir una sopa homogénea.

2 cucharadas de aceite de oliva
1/2 cebolla, en dados
2 pimientos rojos, limpios y en dados
300 ml de caldo de volatería
1 pizca de pimentón

1 hoja de laurel
120 ml de nata
Rehogue los dados de cebolla y de pimiento en el aceite de oliva, incorpore el caldo de volatería, el pimentón y la hoja de laurel y deje que cueza a fuego lento durante 10 minutos. Condimente, pase la mezcla por el pasapurés y cuélela. Añada la nata y condimente.

1 cucharada de aceite de oliva
1 cucharada de dados de cebolla
1 cucharadita de harina
400 ml de leche
150 g de tallos y hojas de albahaca
60 g de espinacas, crudas
Sal, pimienta
Rehogue los dados de cebolla en el aceite de oliva, añada la harina y la leche. Deje que cueza a fuego lento durante 10 minutos, incorpore la albahaca y las espinacas, pase los ingredientes por el pasapurés y condimente. Sirva con tartaletas de gambas.

1 cucchiaio di burro
1 cucchiaio di cipolla tagliata a dadini
1 cucchiaino da farina
200 ml di brodo di pollo
120 ml di panna
100 g di mais fresco
1 presa di curcuma
Imbiondire la cipolla nel burro, aggiungere la farina e bagnare con il brodo di pollo. Portare a cottura e, quando il brodo comincia ad addensarsi, unire la panna e continuare la cottura a fuoco lento. Aggiungere il mais, condire con curcuma, sale e pepe e frullare fino ad ottenere un composto omogeneo.

2 cucchiai di olio d'oliva
1/2 cipolla tagliata a dadini
2 peperoni rossi puliti e tagliati a dadini
300 ml di brodo di pollo
1 presa di paprica
1 foglia di alloro
120 ml di panna

Soffriggere nell'olio d'oliva la cipolla e i peperoni, allungare con il brodo di pollo, unire la paprica e la foglia di alloro e cuocere a fuoco lento per 10 minuti. Condire, passare col passaverdure e quindi al setaccio. Aggiungere la panna, assaggiare e regolare il condimento.

1 cucchiaio di olio d'oliva
1 cucchiaio di cipolla tagliata a dadini
1 cucchiaino di farina
400 ml di latte
150 g di foglie e gambi di basilico
60 g di spinaci crudi
Sale, pepe
Imbiondire la cipolla nell'olio d'oliva, unire la farina e versare il latte. Cuocere a fuoco lento per 10 minuti, aggiungere il basilico e gli spinaci, passare con il passaverdure e condire. Servire con tartine ai gamberetti.

Vida e Caffe

Design, Owners: Rui Esteves, Brad Armitage

Shop 1 Mooikloof, 34 Kloof Street | Gardens, 8001 | Cape Town
Phone: +27 21 421 5755
www.vidaecaffe.com
Opening hours: Mon–Sat 7am to 5 pm, Sun and public holidays 8 am to 5 pm
Average price: R 20
Cuisine: Deli home-made muffins & Portuguese rolls

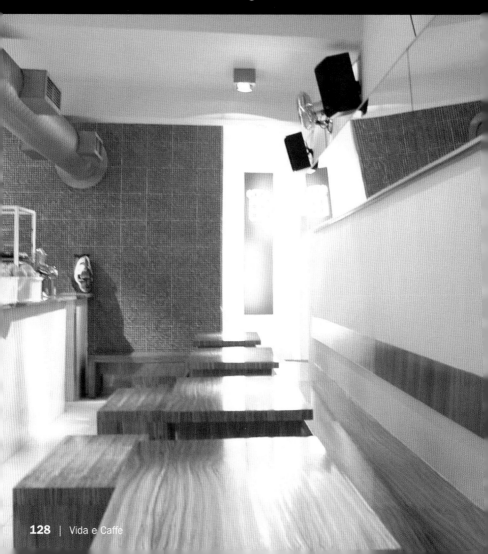

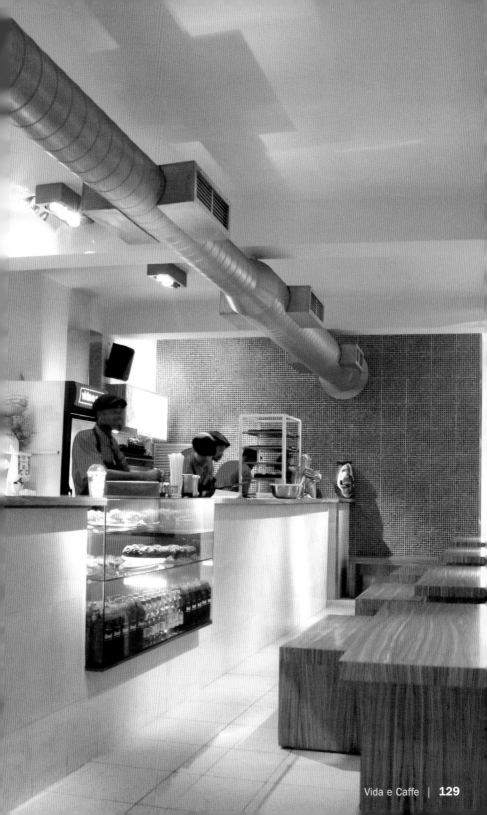

Wakame

Design: Samantha Muhlbauer-Slotar | Chef: Carel van Wyk
Owner: Deon Berg, Roy de Gouveia & Gregory Slotar

1st Floor, Surrey Place, Beach Road | Mouille Point, 8005 | Cape Town
Phone: +27 21 433 23 77
www.wakame.co.za
Opening hours: Mon–Fri noon to 3 pm, 6 pm to 10:30 pm, Fri–Sun noon to 3 pm,
6:30 pm to 10:30 pm
Average price: R 80
Cuisine: Pacific rim & sushi bar
Special features: Robben Island views

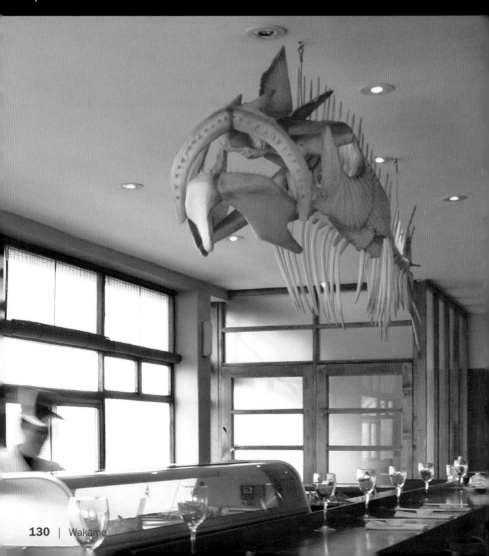

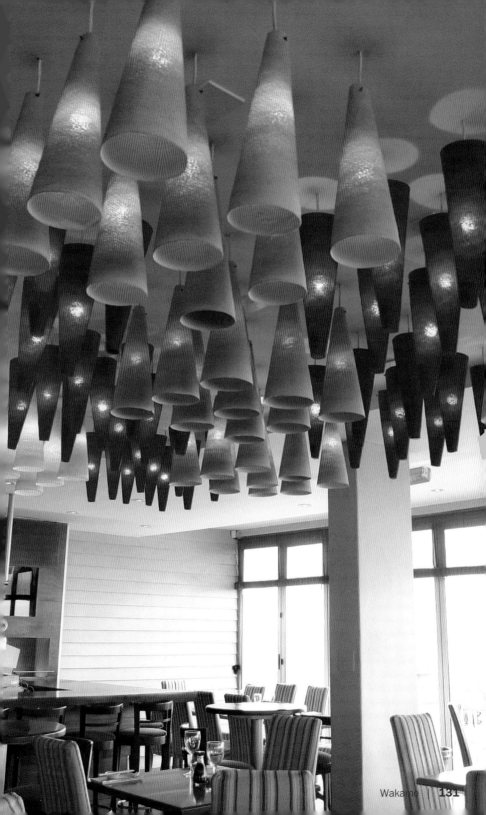

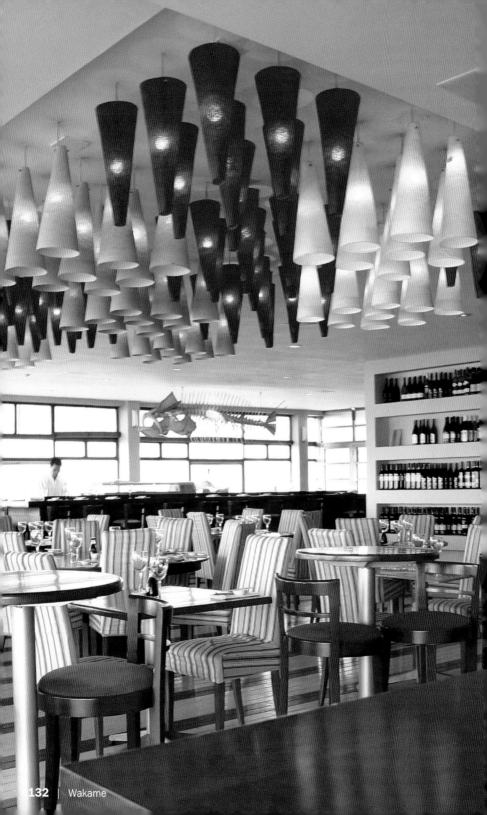

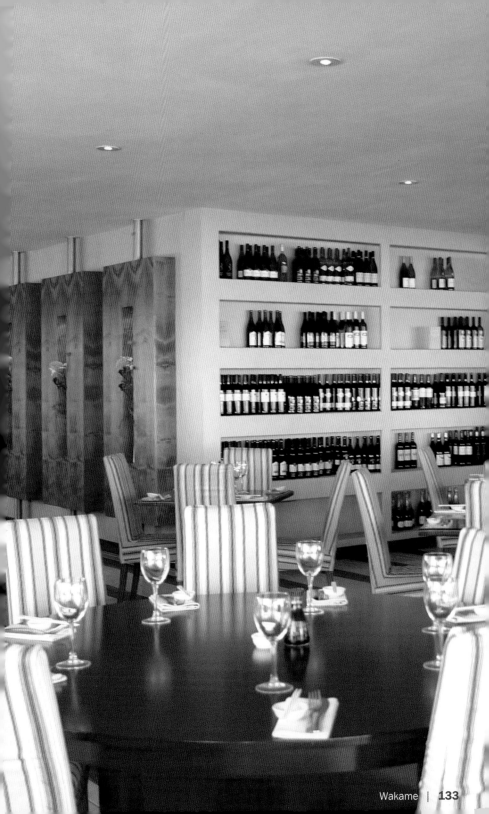

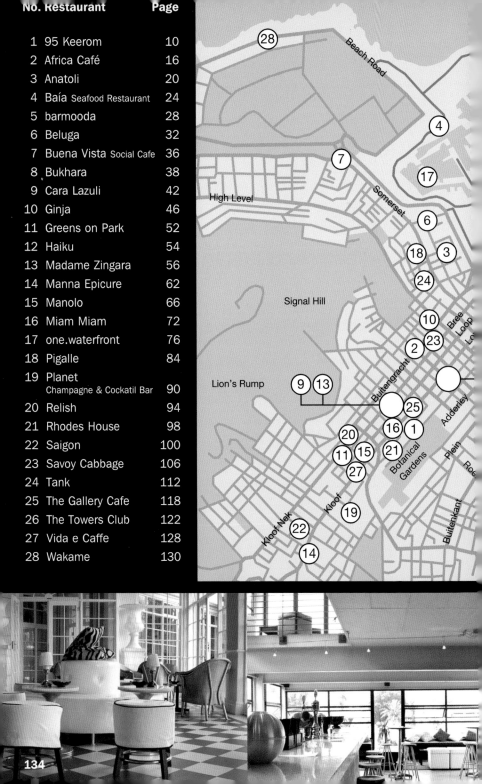

Beach Road

Somerset

High Level

Signal Hill

Lion's Rump

Bree Loop

Buitengracht

Botanical Gardens

Adderley

Plein

Kloof Nek

Kloof

Buitenkant

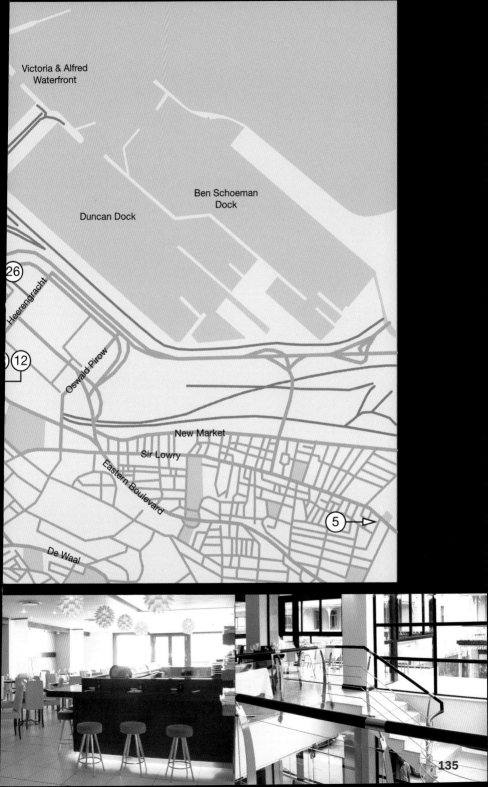

Victoria & Alfred
Waterfront

Ben Schoeman
Dock

Duncan Dock

26

Heerengracht

12

Oswald Pirow

New Market

Sir Lowry

Eastern Boulevard

5

De Waal

Cool Restaurants

Size: 14 x 21.5 cm / 5 $\frac{1}{2}$ x 8 $\frac{1}{2}$ in.
136 pp, Flexicover
c. 130 color photographs
Text in English, German, French,
Spanish, Italian or (*) Dutch

Other titles in the same series:

Amsterdam
ISBN 3-8238-4588-8

Barcelona
ISBN 3-8238-4586-1

Berlin
ISBN 3-8238-4585-3

Brussels (*)
ISBN 3-8327-9065-9

Chicago
ISBN 3-8327-9018-7

Cologne
ISBN 3-8327-9117-5

Côte d'Azur
ISBN 3-8327-9040-3

Frankfurt
ISBN 3-8237-9118-3

Hamburg
ISBN 3-8238-4599-3

Hong Kong
ISBN 3-8327-9111-6

Istanbul
ISBN 3-8327-9115-9

Las Vegas
ISBN 3-8327-9116-7

London 2nd edition
ISBN 3-8327-9131-0

Los Angeles
ISBN 3-8238-4589-6

Madrid
ISBN 3-8327-9029-2

Mallorca/Ibiza
ISBN 3-8327-9113-2

Miami
ISBN 3-8327-9066-7

Milan
ISBN 3-8238-4587-X

Munich
ISBN 3-8327-9019-5

New York 2nd edition
ISBN 3-8327-9130-2

Paris 2nd edition
ISBN 3-8327-9129-9

Prague
ISBN 3-8327-9068-3

Rome
ISBN 3-8327-9028-4

San Francisco
ISBN 3-8327-9067-5

Shanghai
ISBN 3-8327-9050-0

Sydney
ISBN 3-8327-9027-6

Tokyo
ISBN 3-8238-4590-X

Toscana
ISBN 3-8327-9102-7

Vienna
ISBN 3-8327-9020-9

Zurich
ISBN 3-8327-9069-1

To be published in the
same series:

Dubai
Copenhagen
Geneva

Moscow
Singapore
Stockholm

teNeues